men in this *town*

London, Tokyo, Sydney, Milan, New York

To the men in my life, here and gone.

Giuseppe Santamaria

men in this *town*

London, Tokyo, Sydney, Milan, New York

hardie grant books
MELBOURNE · LONDON

TOWNS

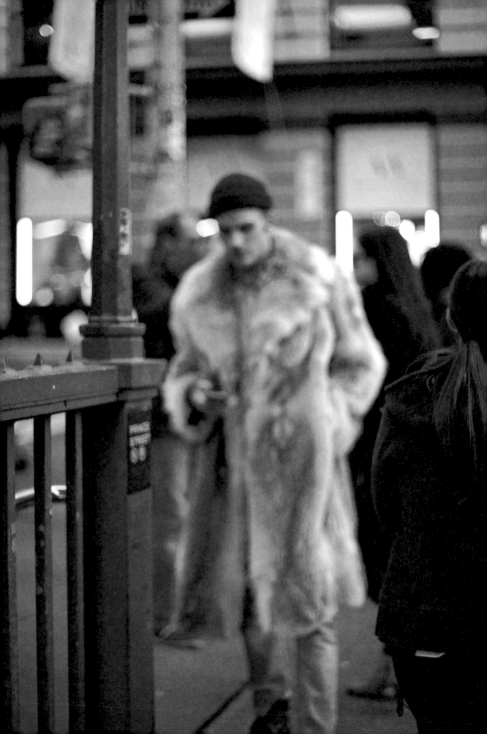

men in this *town*

In 2010 I began *meninthistown.com*, an online street-style journal capturing men with a distinct look in their natural habitat. From various locations in Sydney or wherever my travels brought me, I was looking to photograph the everyday man whose dress sense spoke volumes about his character.

I have since been photographing the streets of Sydney, Tokyo and New York on a regular basis and, on the road to producing this book, found myself in London and Milan.

This is a snapshot of how men in these five towns around the world were expressing themselves through fashion early in this decade.

Giuseppe Santamaria

TOWN

London

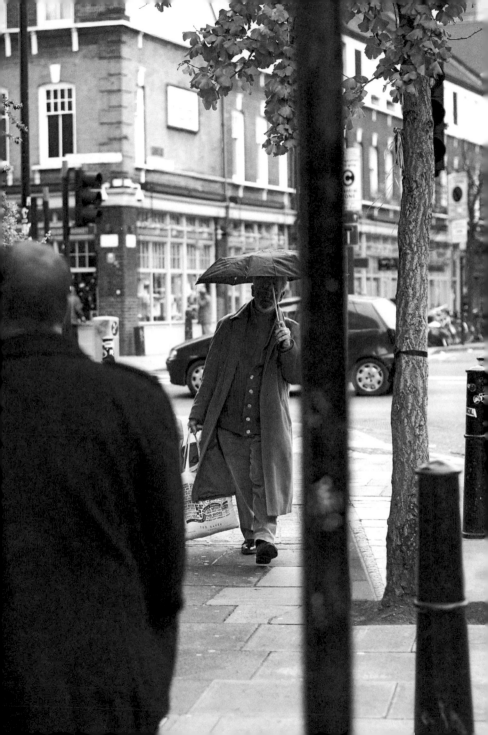

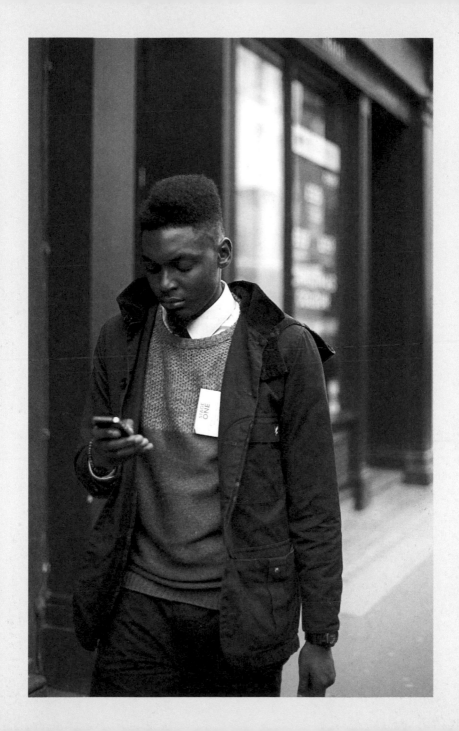

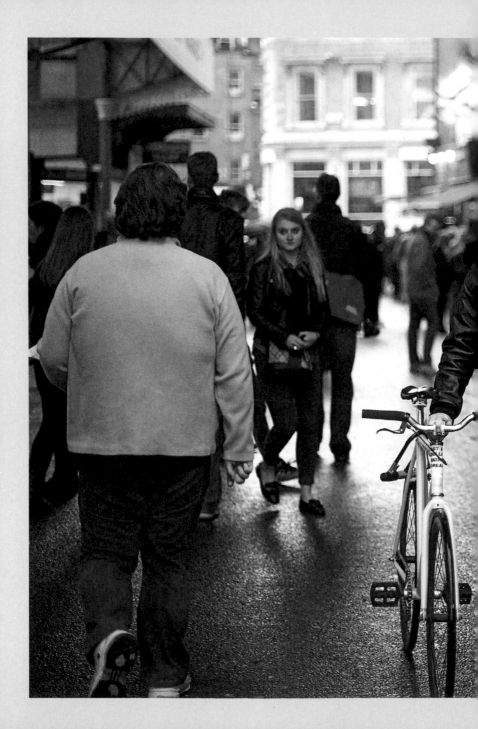

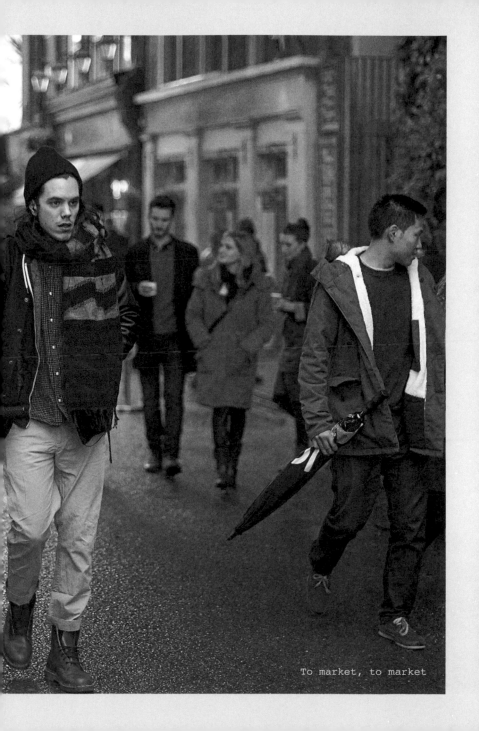

To market, to market

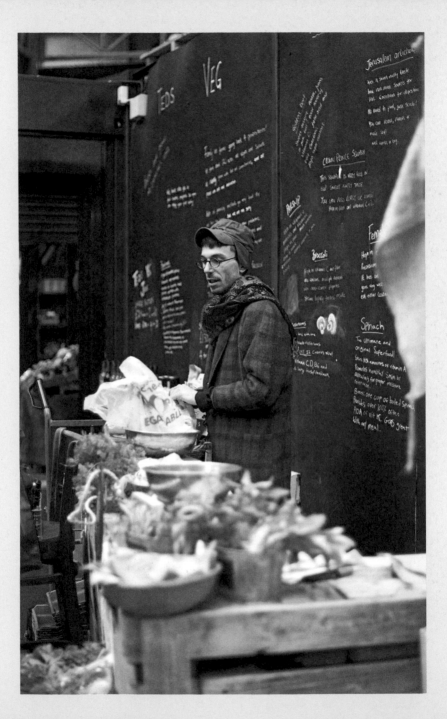

Captured in the East End of London. The silhouette of a Russian Cossack with a pop of colour is reminiscent of Saint Basil's Cathedral in Moscow.

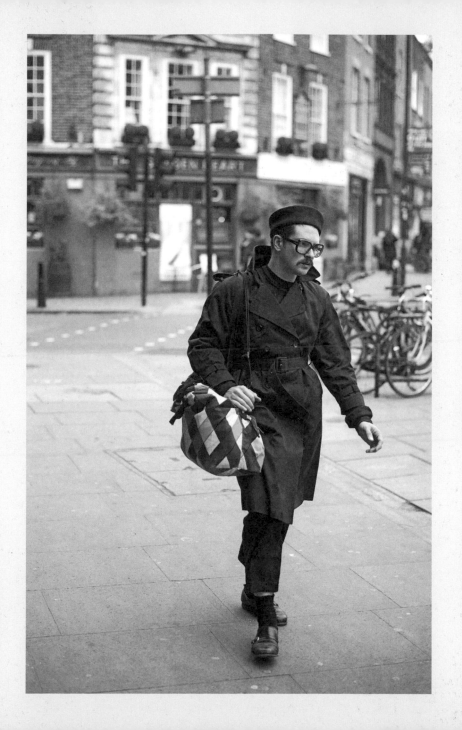

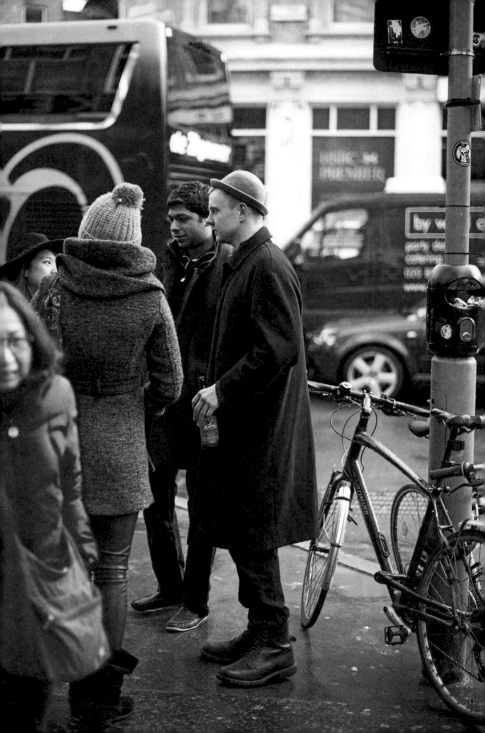

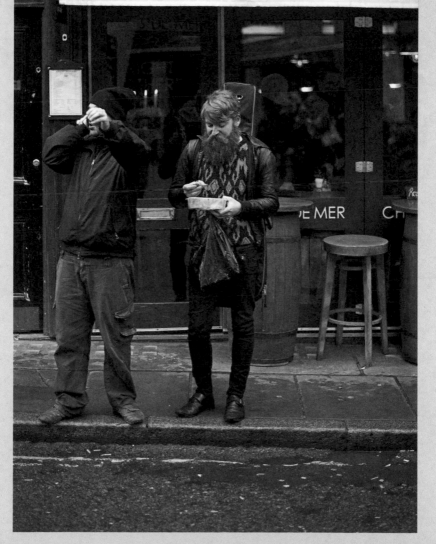

Pom-pom

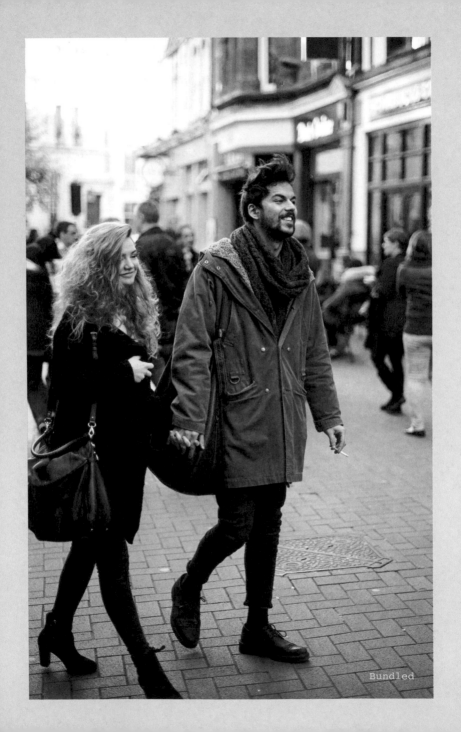

Bundled

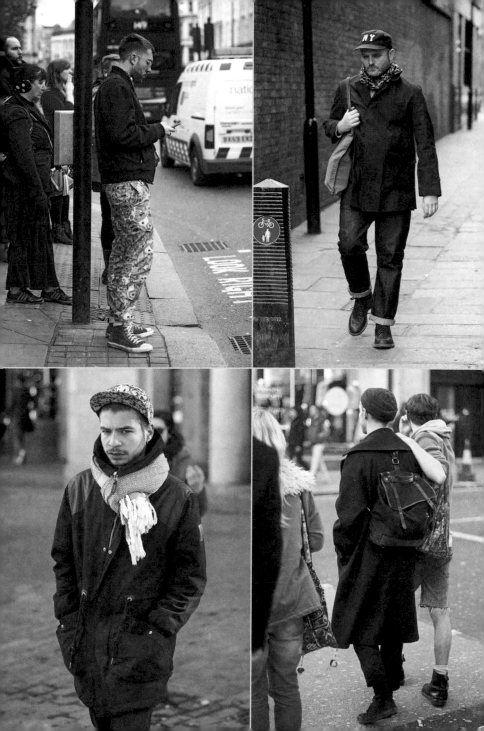

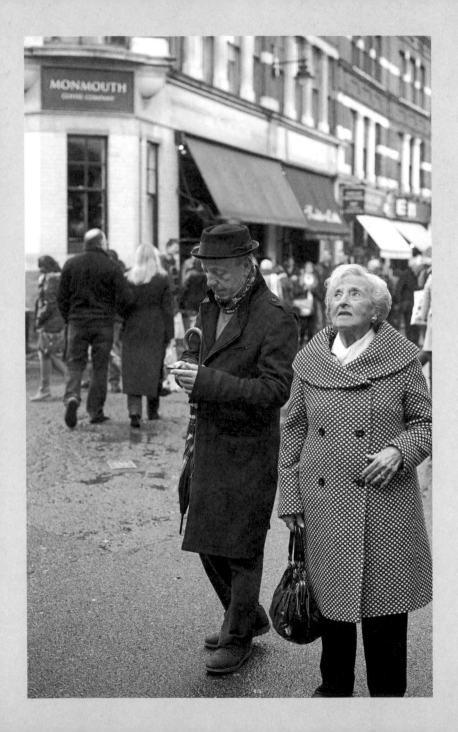

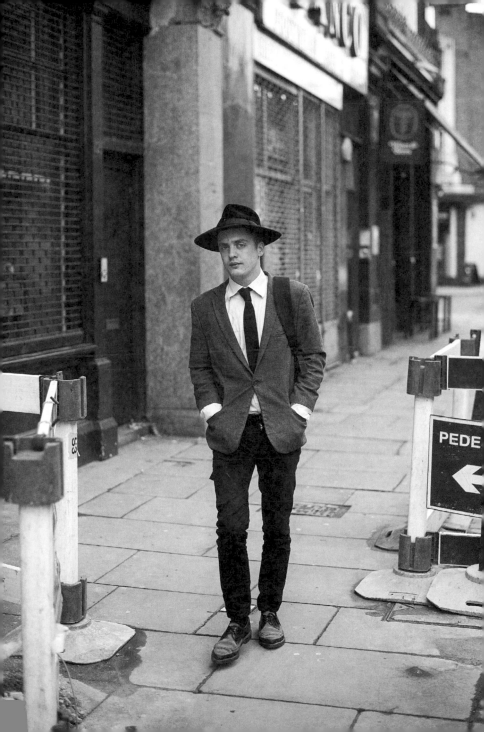

Plaid back

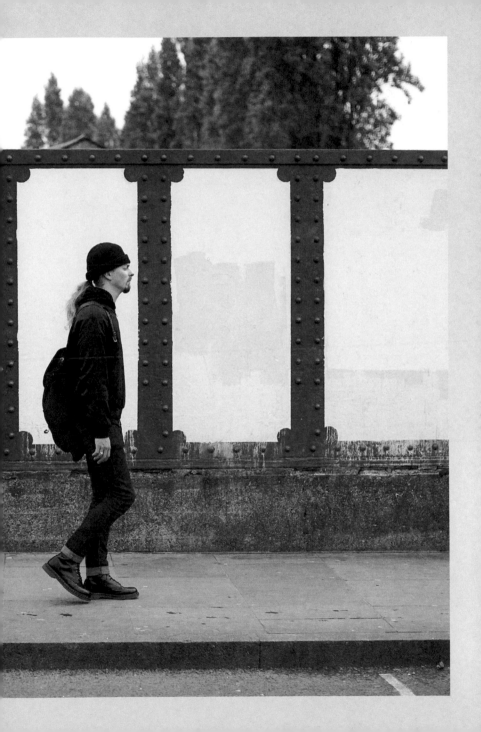

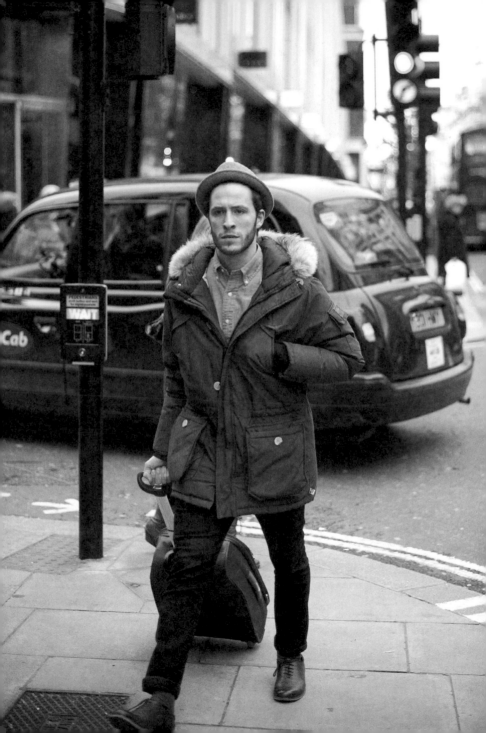

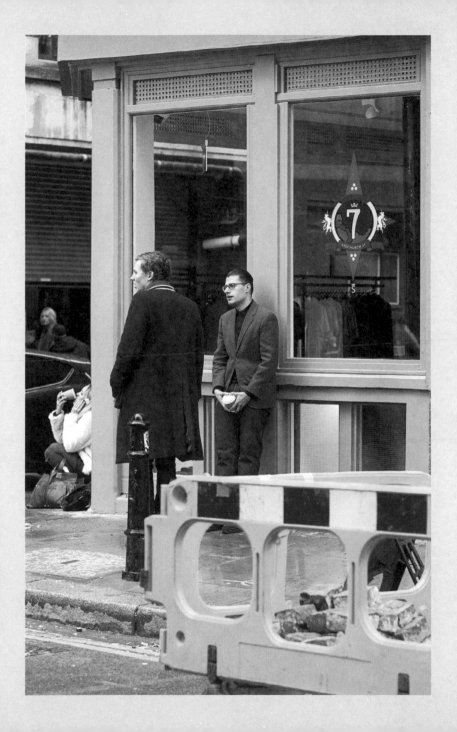

Dan Rookwood in *London*

I met Dan Rookwood at his home in Richmond, an affluent area of south-west London. The voice of menswear for a new generation, Dan, now the US editor at Mr Porter, has witnessed a resurrection of men's fashion in his hometown that has redefined style for the London man.

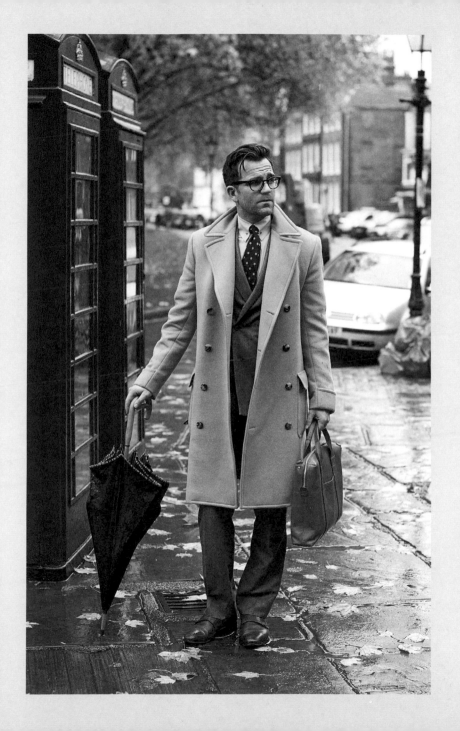

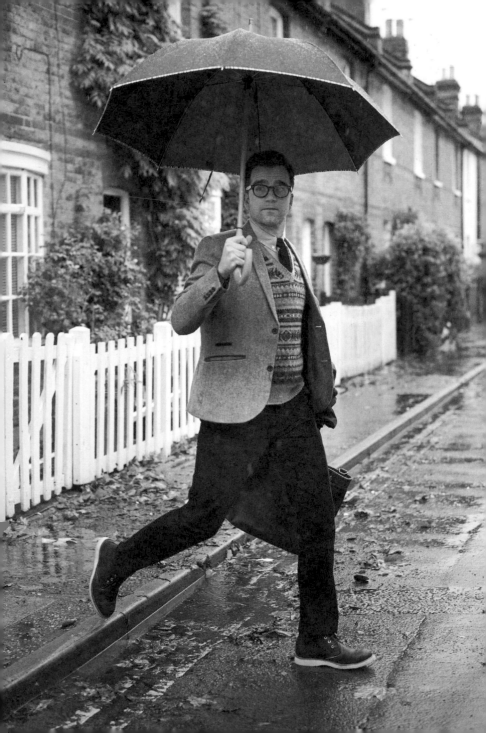

On his personal style
During the week, my style is quite buttoned-up. It can be rather preppy – a smart, tailored Mayfair look. I tend to wear a shirt and tie with a blazer or suit. On the weekend it's a bit more casual, more dressed-down. I like heritage classics: a good-quality jersey sweatshirt, a bomber or baseball jacket and a nice pair of sturdy brogue boots. But I also like to wear Nike Air Max. I have a sizeable collection of them. It's just an affection that I've carried from childhood into this never-ending adolescence.

What you wear and the way you wear it says a lot about you. I try to dress the part. People expect me to be quite dapper and I like that; I love it in fact. I feel like I stand a bit taller when I'm wearing a suit. I feel like a million dollars.

On his style progression
As a child I dressed more smartly than my peers. I think that came from the men in my family. I have an older brother, and he always had the sort of wardrobe that I envied. I would wait until he went out then steal things from his closet, even though they were far too big for me.

My father has always worn a shirt and tie. Both of my grandfathers were resplendent. They were from the wartime generation where things were done properly; shoes were polished, ties were firmly in their collar, jackets were brushed down and hair was combed. Everything had its place. There was a gentlemanly refinement that was passed down and I've picked up on that. I'm doing it in my own way and I'm proud to carry on the family tradition.

On his interest in fashion
After university, I moved to London and started working in the media. One of my first magazine jobs was at *Men's Health*. I contributed to the style section and the

style editor took me under his wing, taking me to shows in Milan and London. The editor wanted me to be out and about at events and represent the magazine, and I was encouraged to look the part. I got into menswear almost by accident, but I found that I loved it.

On modern London style

There is a real heritage and tradition to British style but a modern twist is breathing new life into it. It's not as stuffy as it once was. The cut is more contemporary and men are wearing traditional pieces in new and exciting ways. There's a new generation developing an appreciation for the quality and craftsmanship of British garments.

I think we've really upped our game in London over the last decade. There was a time in the late nineties/ early naughties when it was almost a badge of honour to dress like a slob. There was this laddish culture – beers, cigarettes, crisps – and it was cool not to care. We've completely inverted that now. There's no stigma attached to caring about how you look.

We've got the West End, which has always been about tailoring and luxury – Savile Row, Bond Street, Jermyn Street, Mount Street. But now we've got this really interesting East End of emerging menswear designers around Shoreditch and Hackney focusing on contemporary streetwear. These two styles are being mixed. Tinie Tempah would be a perfect poster boy for that. He does it really well. I think it's a fresh and inventive way of bringing the old and the new together.

When you see London Collections: Men [a British menswear showcase], it's this amazing splicing of the West End and East End. This gives London a unique blend of brilliance in terms of menswear. I think that's why we're having such a good moment and getting respect around the world – because we have this scene going on. It's on fire.

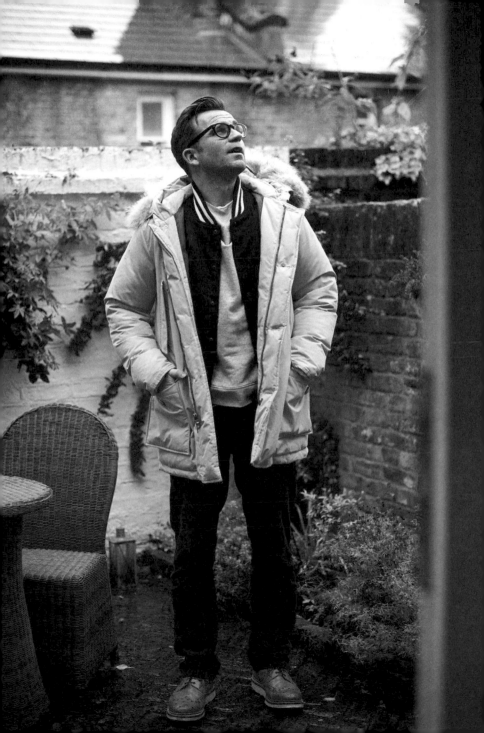

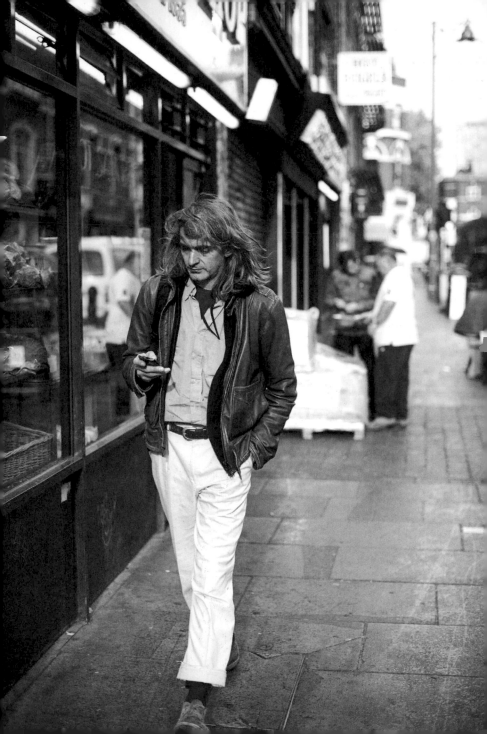

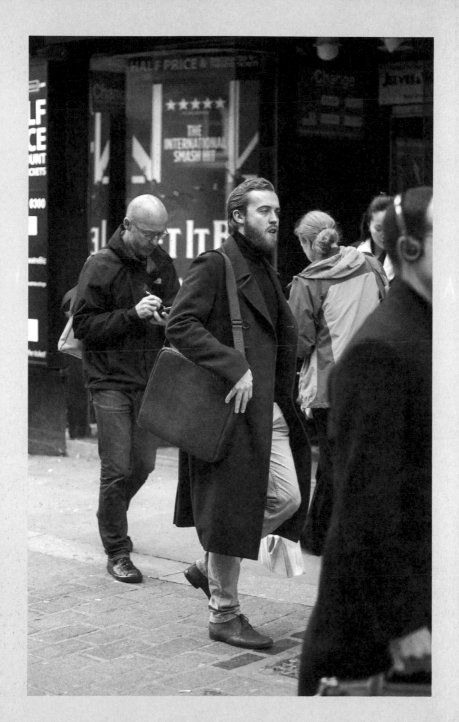

IMPROVED
LIGHTING
AND SECURI
SYSTEMS

Under

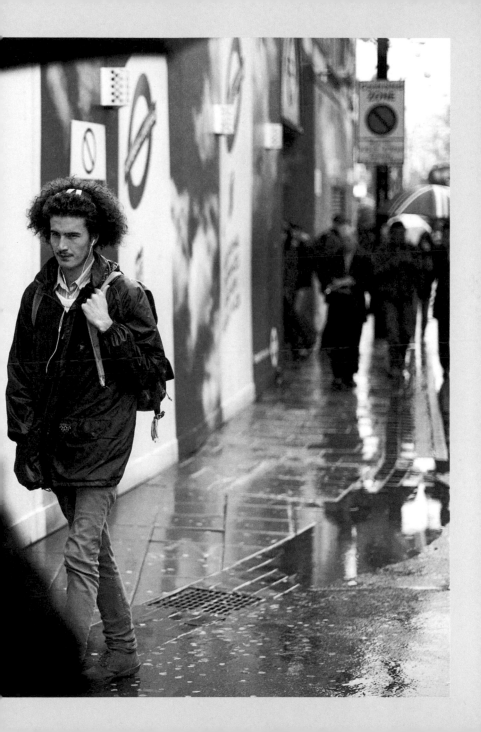

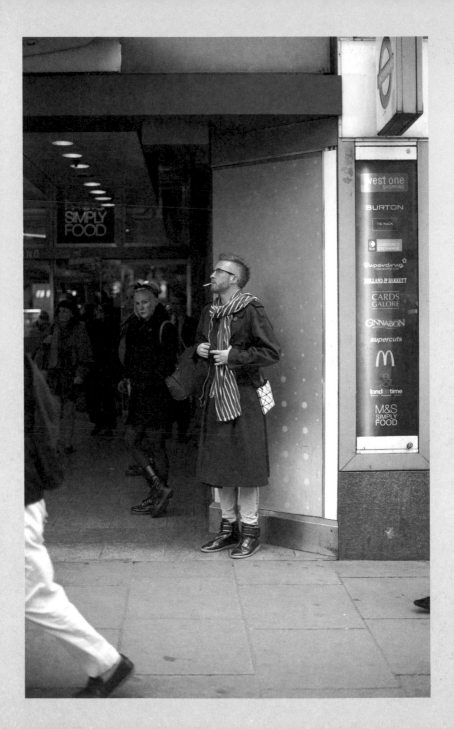

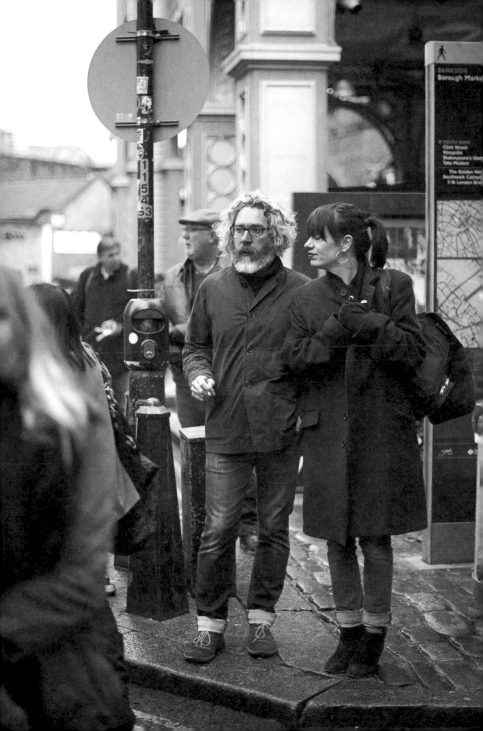

Burgundy and blue stepping out of the Louis Vuitton shop on Bond Street.

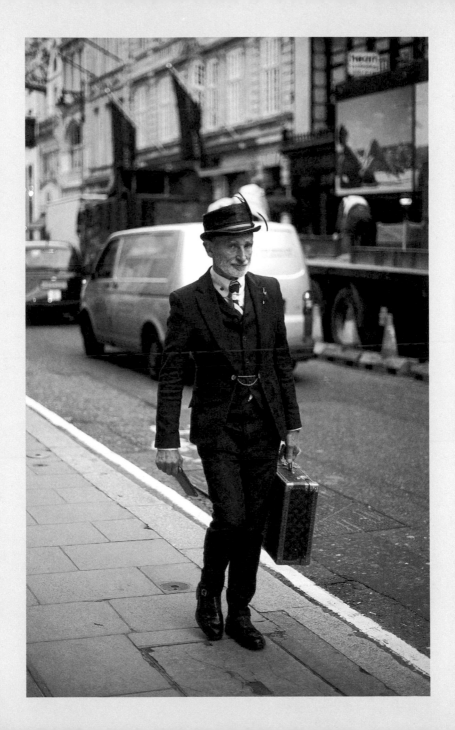

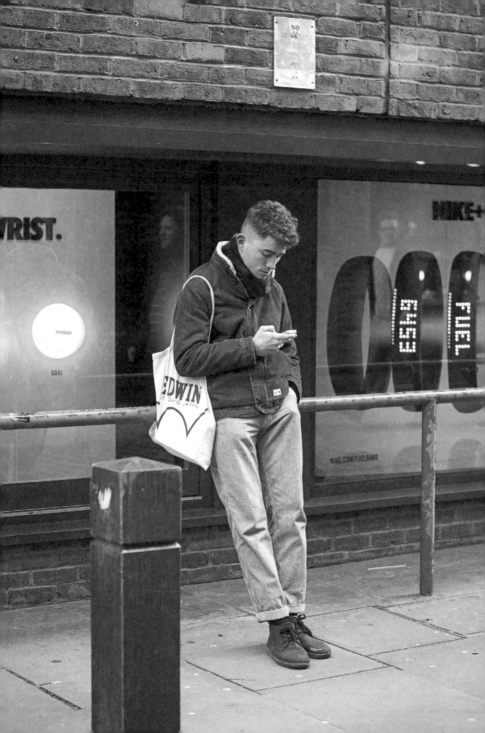

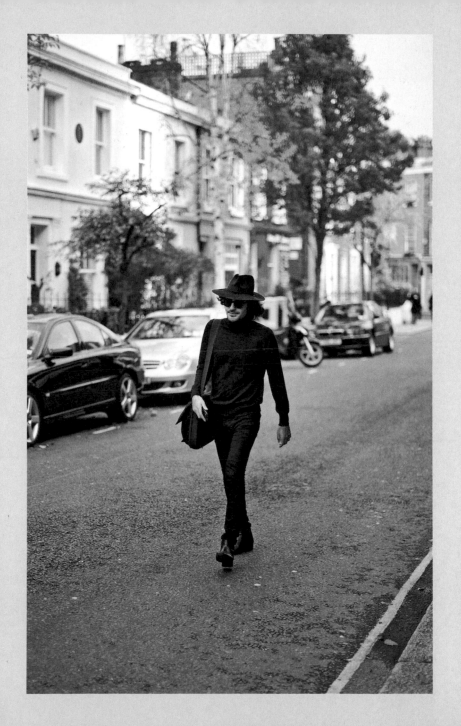

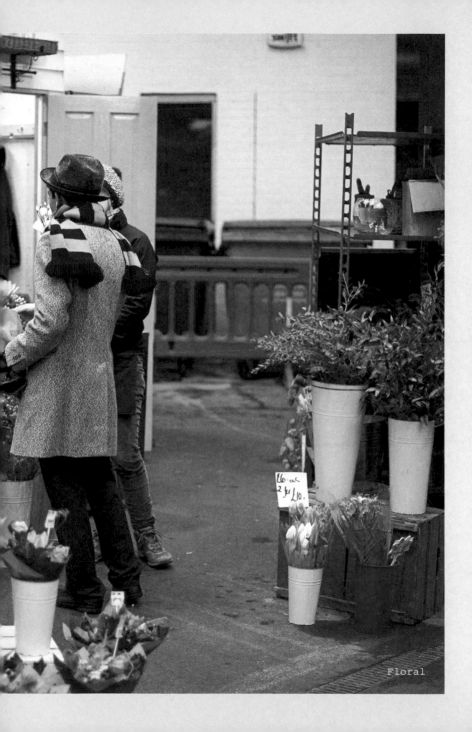

Floral

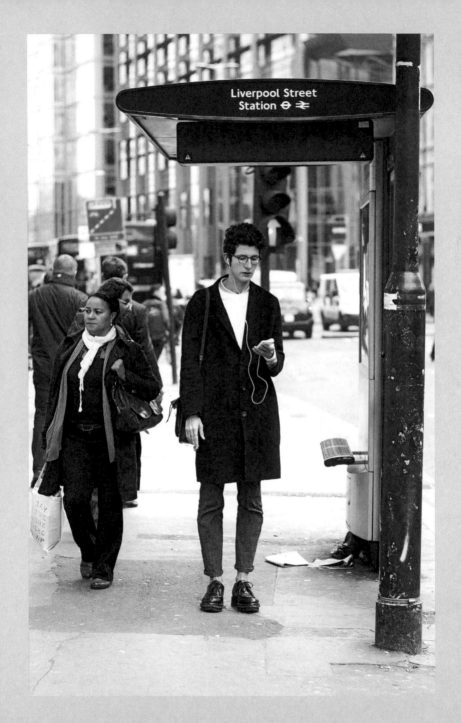

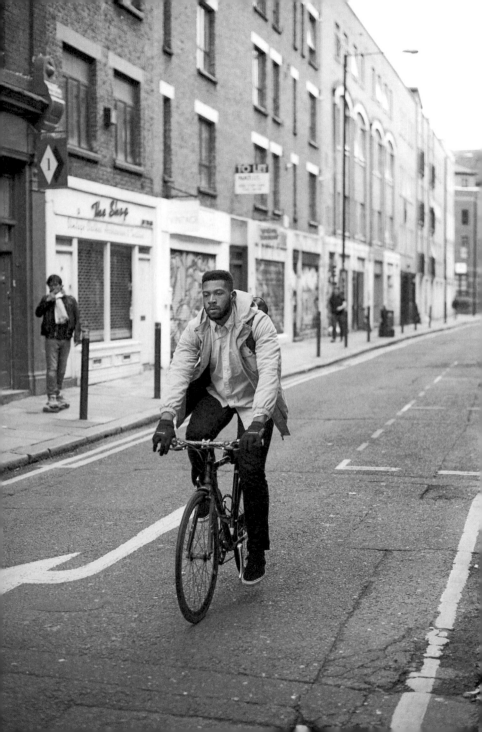

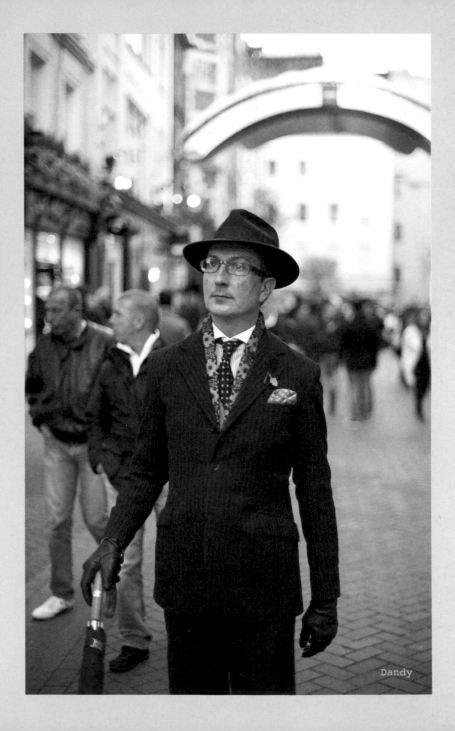

Dandy

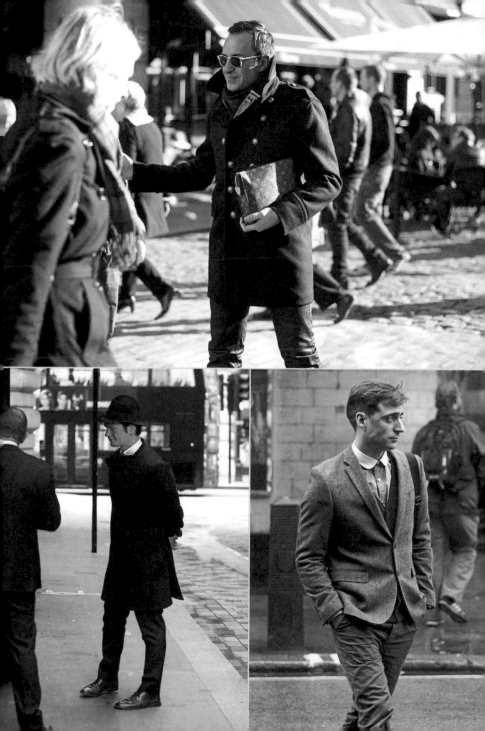

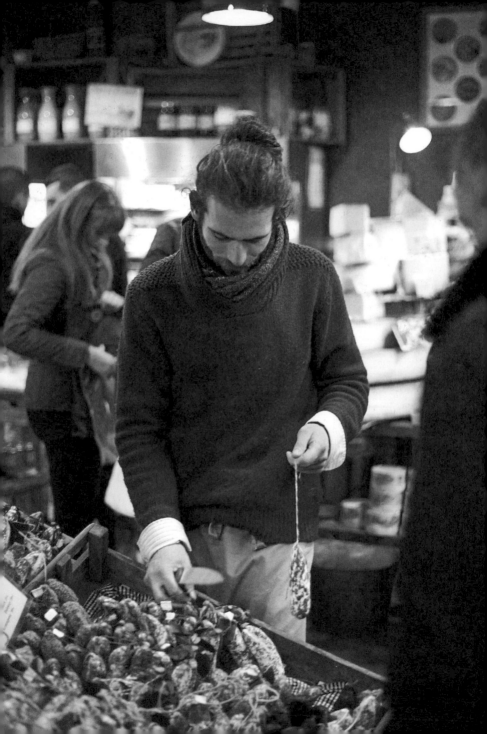

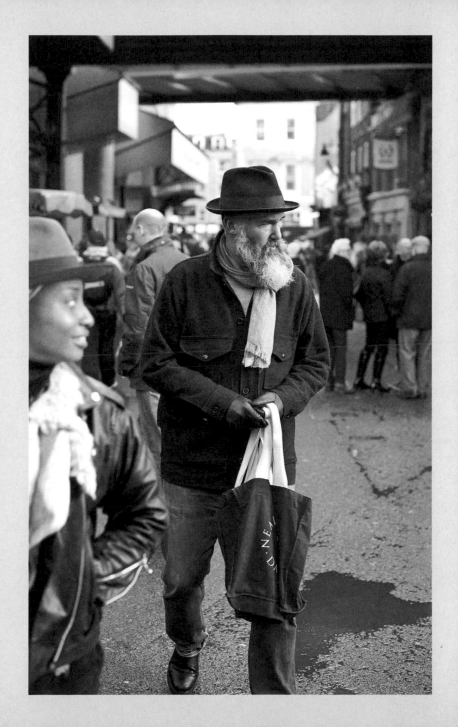

I have always admired the art of accessorising. Sometimes it's something simple like this man's wooden beaded necklace and bronze-plated belt.

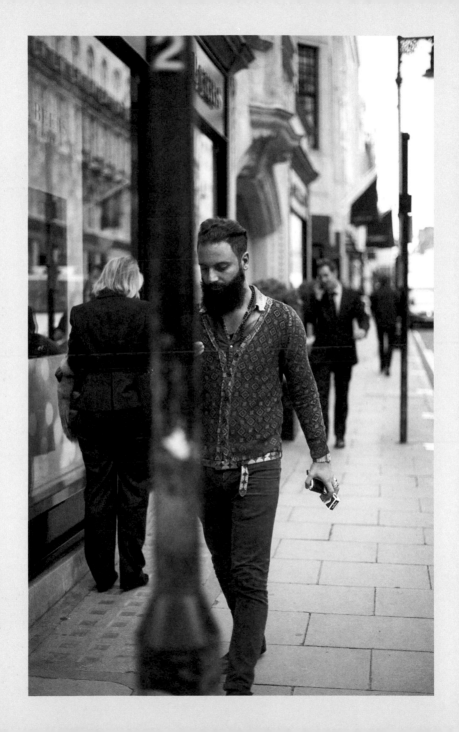

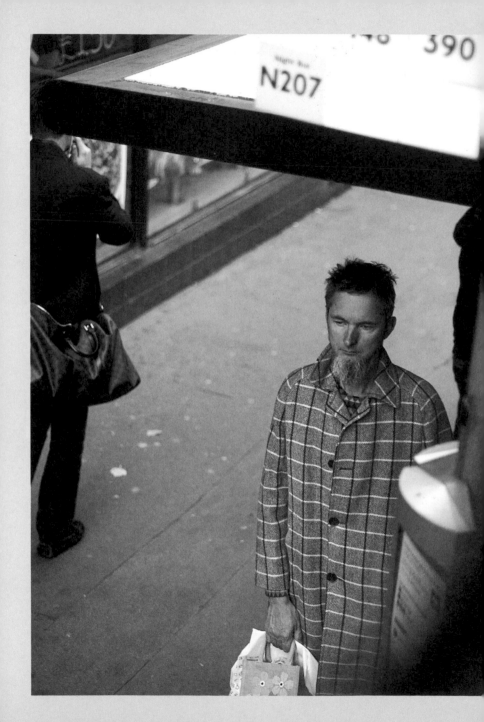

London grid

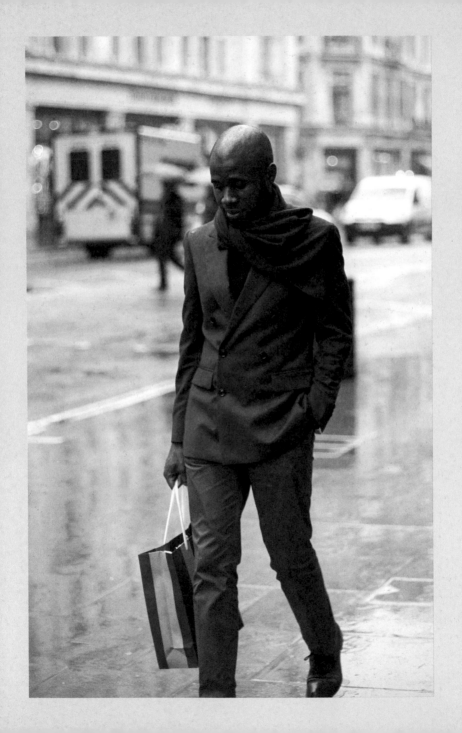

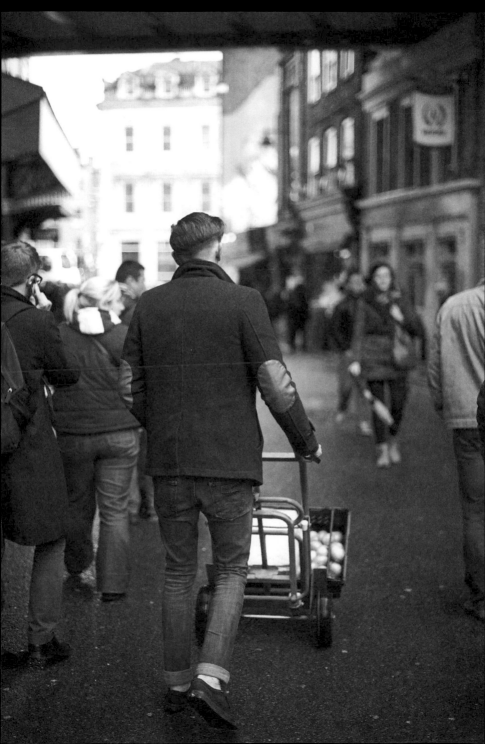

Tokyo

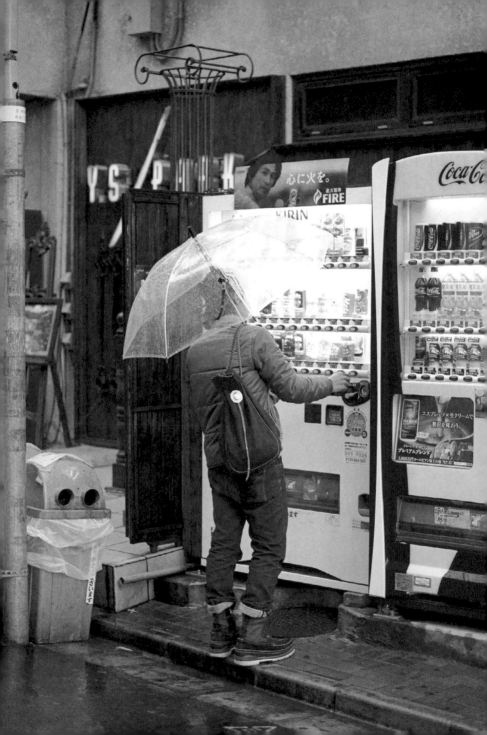

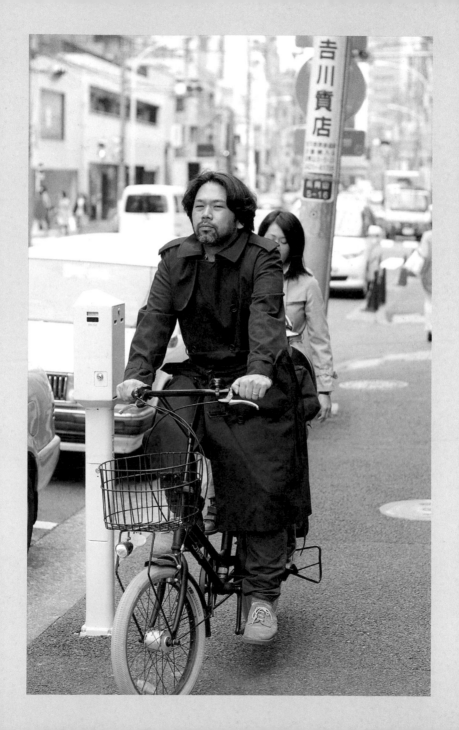

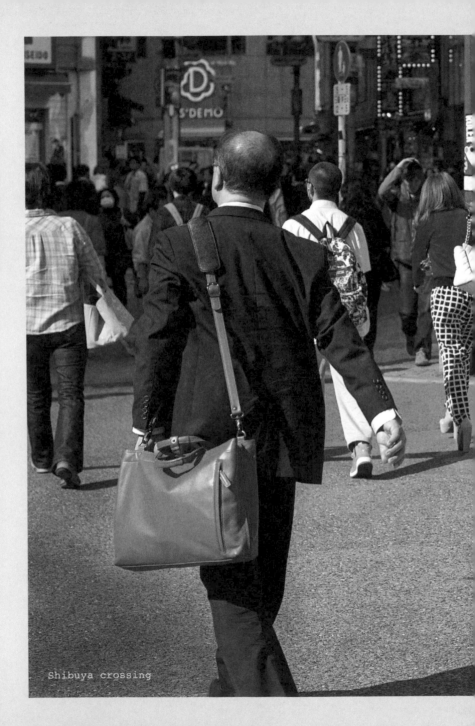

Shibuya crossing

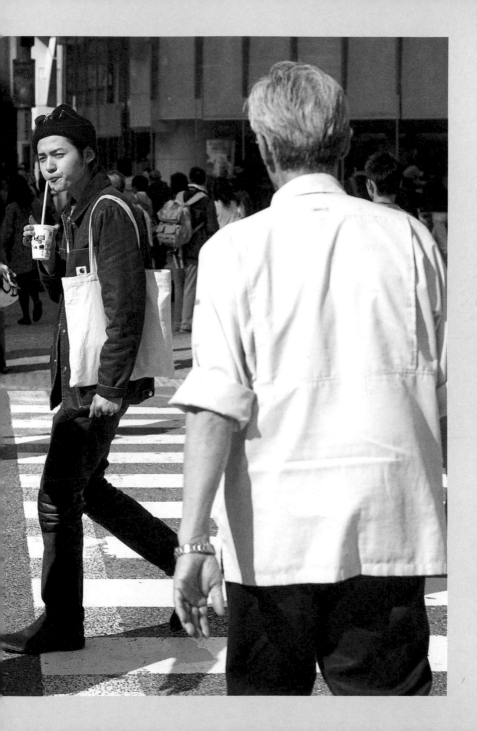

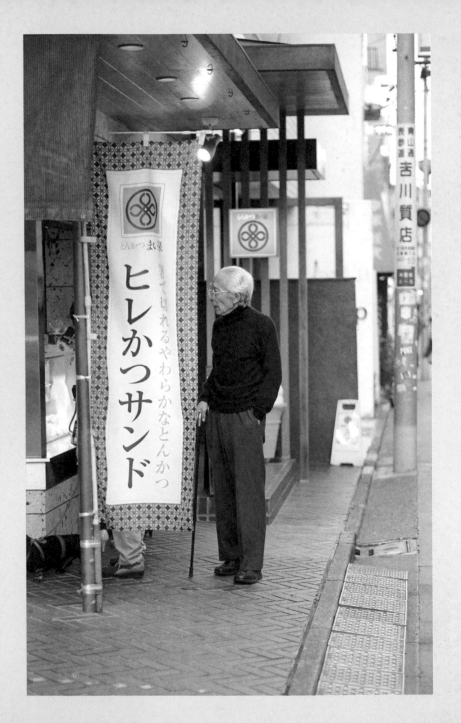

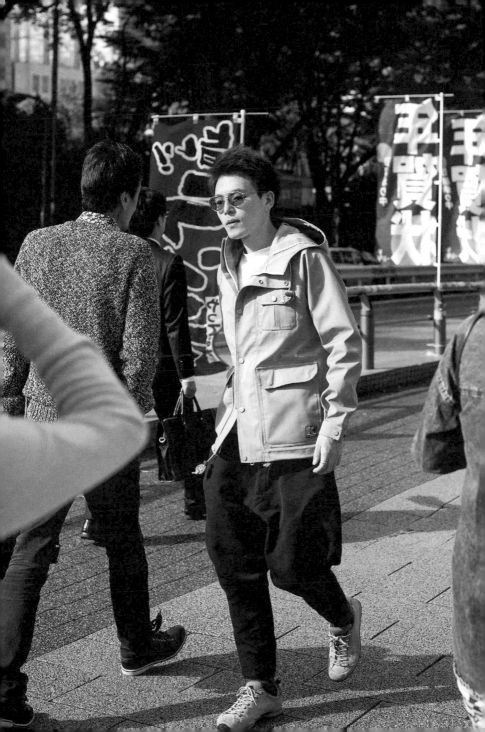

My eye is drawn to one-of-a-kind pieces. I appreciate Japan's love of unique accessories, like this patchwork bag.

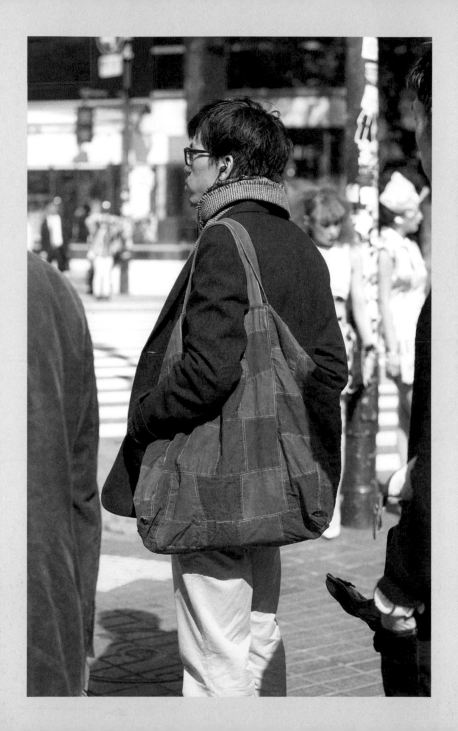

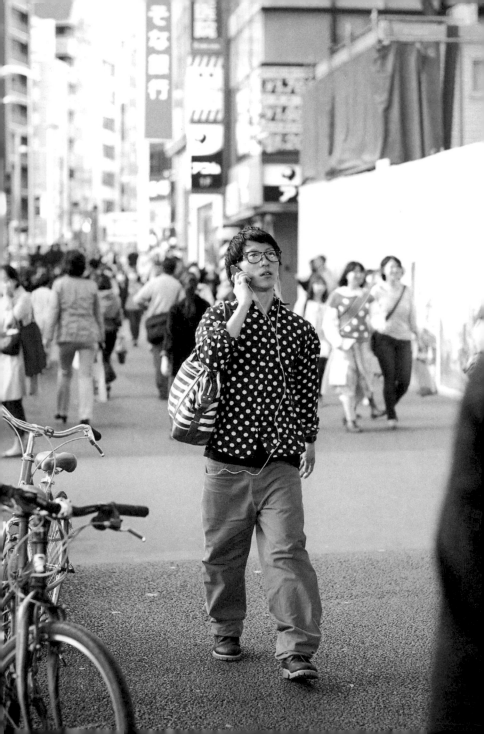

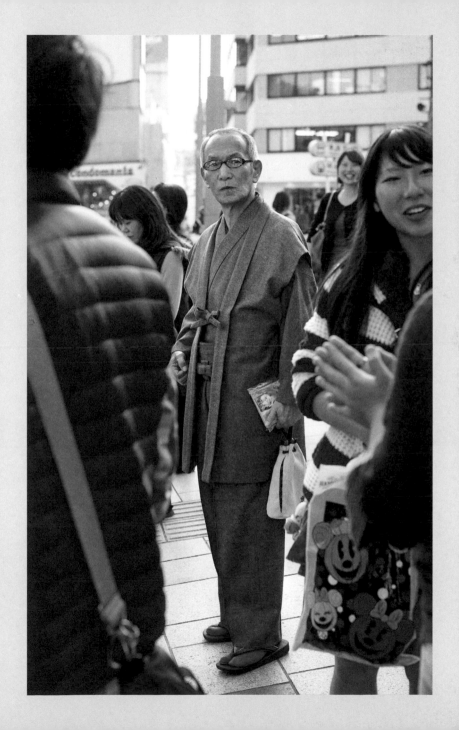

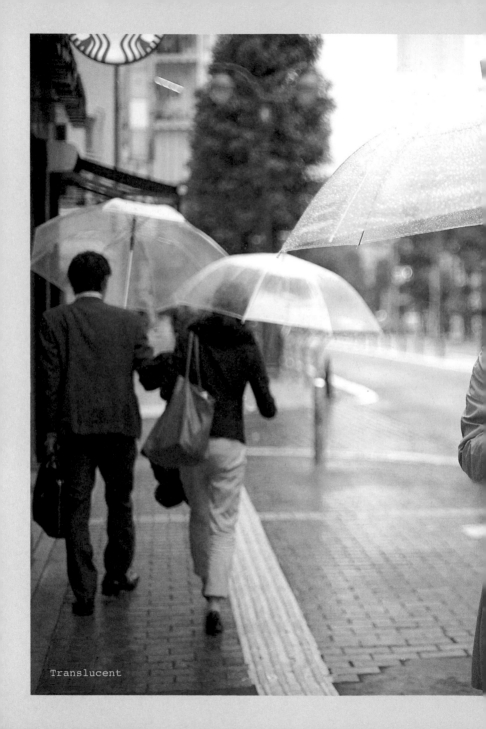
Translucent

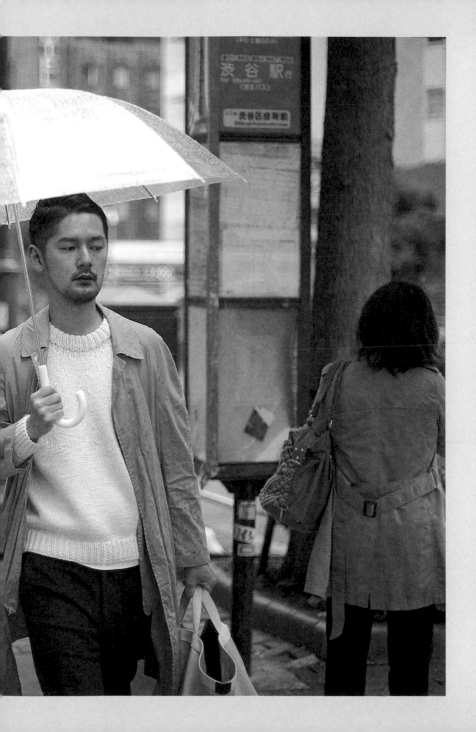

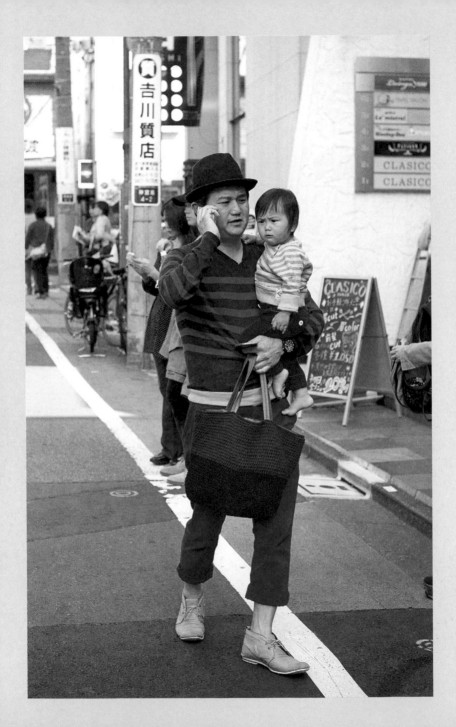

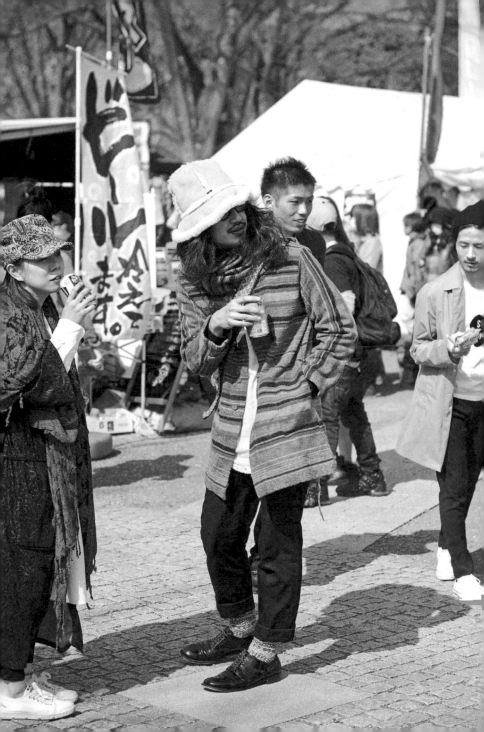

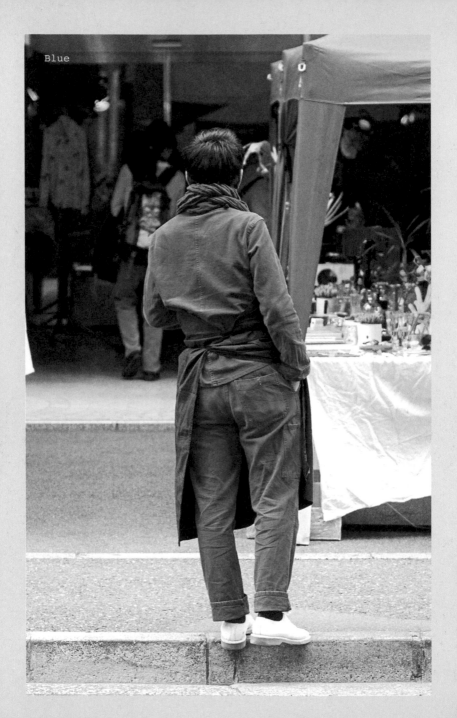

Blue

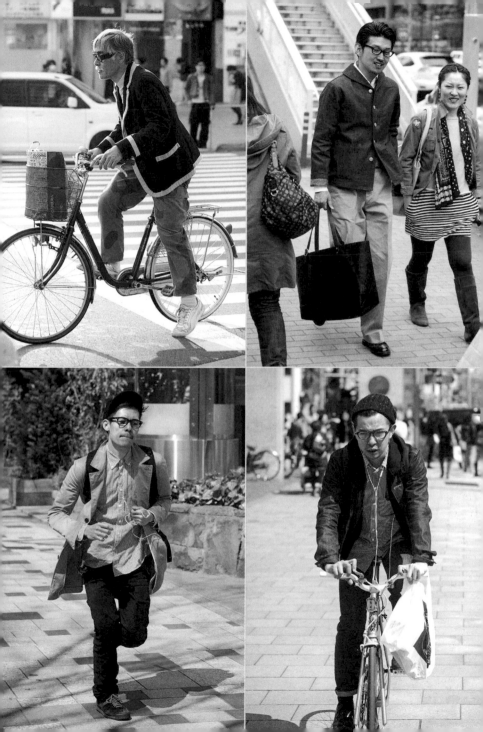

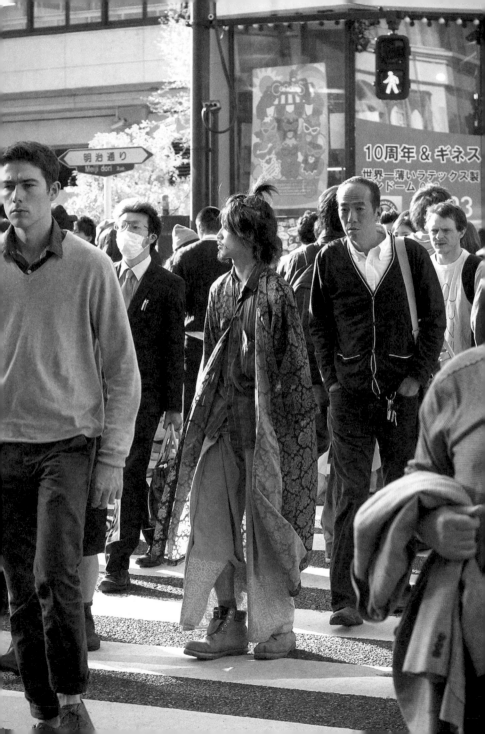

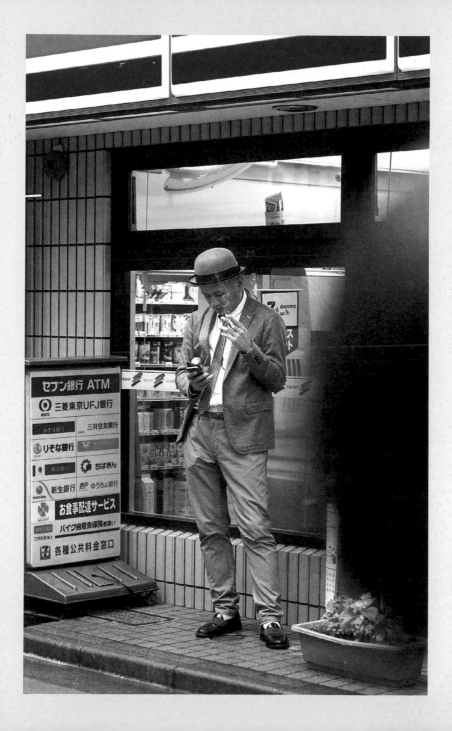

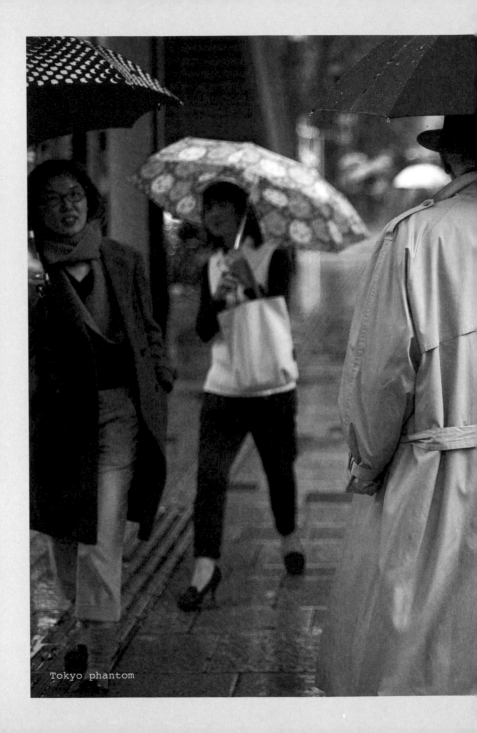
Tokyo phantom

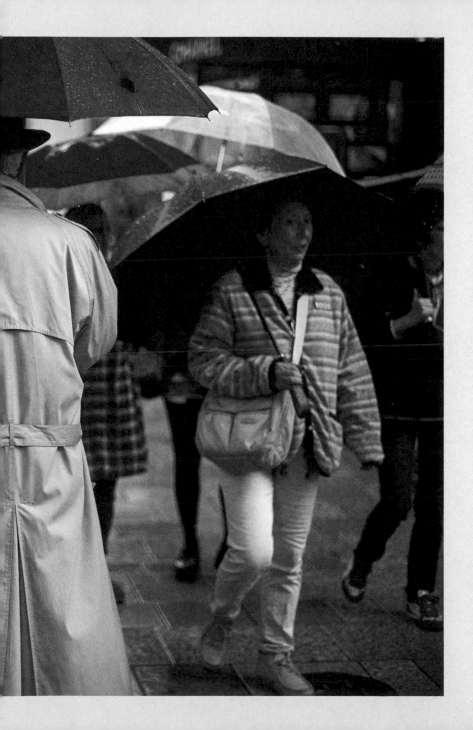

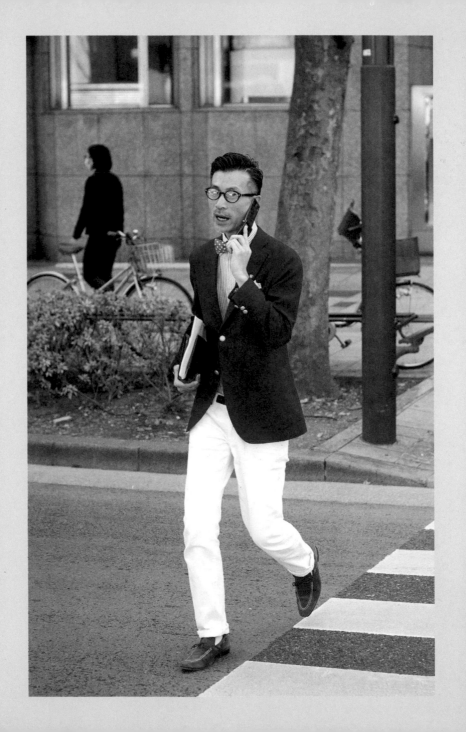

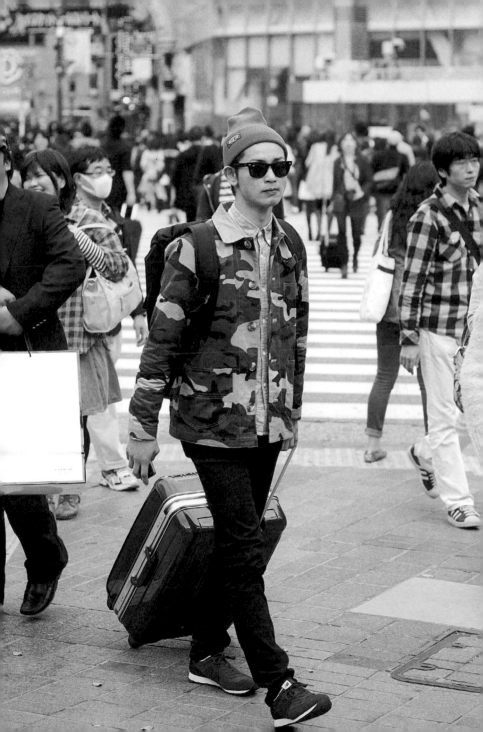

Taisuke Nakamuro in *Tokyo*

Taisuke runs his own fashion-focused PR agency in the Shibuya ward of central Tokyo. From the moment we met, his enthusiasm for fashion was evident in his meticulous style. Whether hip-hop star or Tokyo Dandy, Taisuke gives it his all.

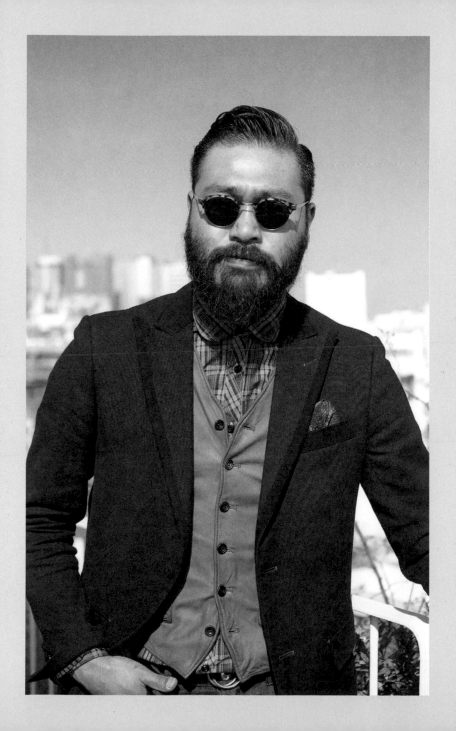

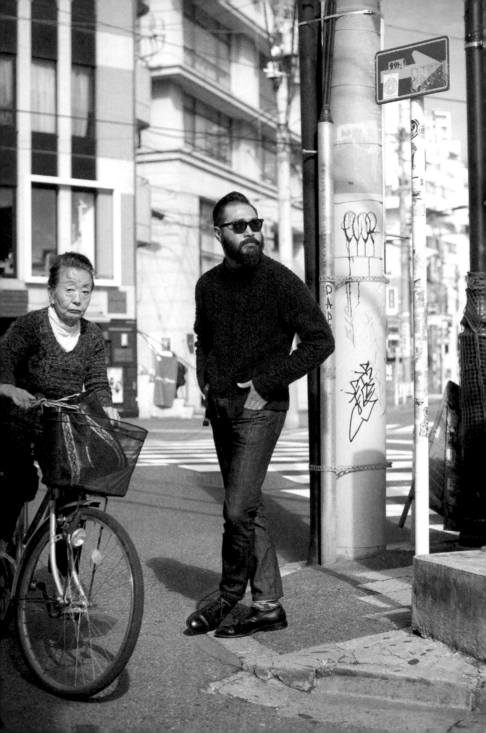

On his personal style

I think my style changes as I get older. I've always worn what I think looks best on me at a particular time in my life. At the moment, it's a bit more sophisticated, but I still have fun with different pieces.

On his style progression

My parents used to buy my clothes when I was young. So that has changed. There was a lot of Ralph Lauren, which was common in Tokyo at the time.

I really started to experiment with fashion when I was about 12 or 13. I watched a lot of hip-hop videos from the United States and was greatly influenced by the hip-hop dance scene. I wore a lot of baggy sweaters, crazy denim; I even had dreadlocks. I gave it 100%.

But as I got older and started working, my environment changed and so did my style. It was a natural progression. I grew through my experiences and so did my clothes.

On Tokyo fashion

The *wabi-sabi* aesthetic is a great influence in Japanese fashion. *Wabi-sabi* entails beauty, but also imperfection, ephemerality and incompleteness.

There are many different styles that live in Tokyo, from street to formal. It's a strange city in that there isn't a set look that people follow. Style in Tokyo is unique, ranges greatly and is always in a state of reinvention.

In saying that, the basics of how we dress stem from the kimono. The kimono was a very formal style of dress. There was a proper way to wear it and you had to respect the rules. In modern times, whether we dress like a hip-hop star or a British dandy, we do it right and respect the way it's meant to be worn.

At the end of the day, we live in the world we dress up for. And if it doesn't exist, we create it.

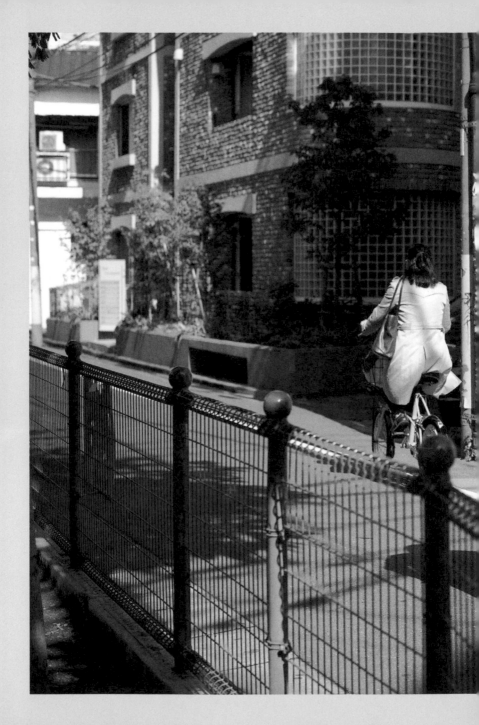

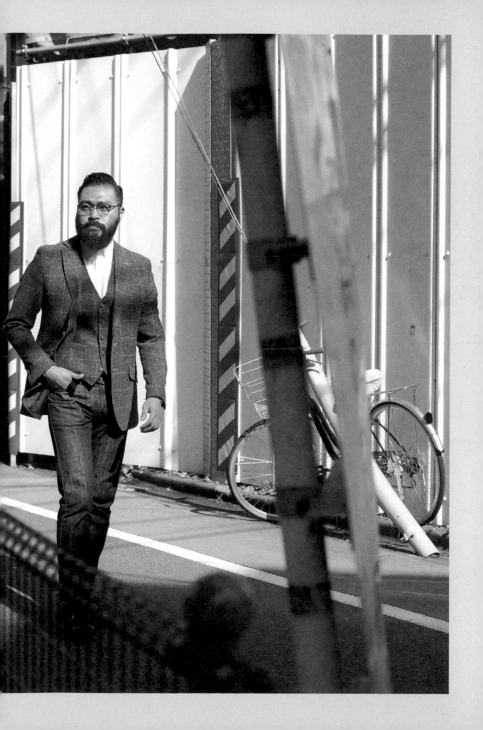

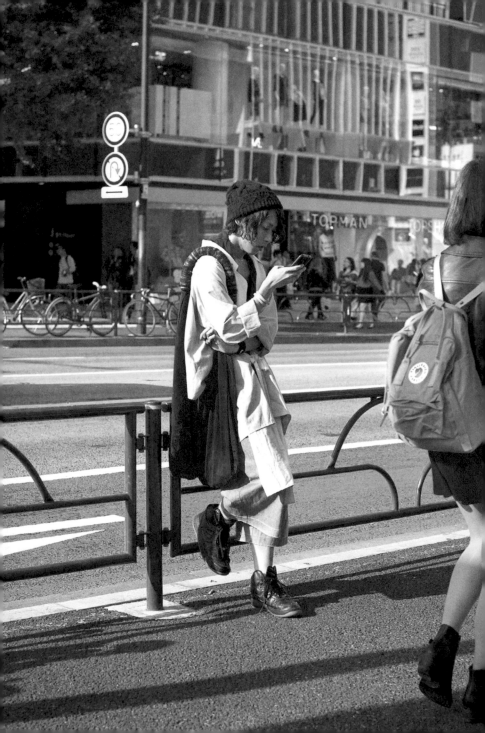

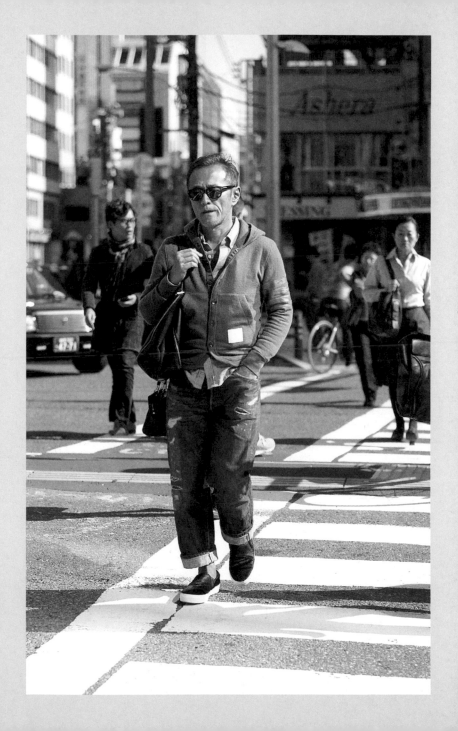

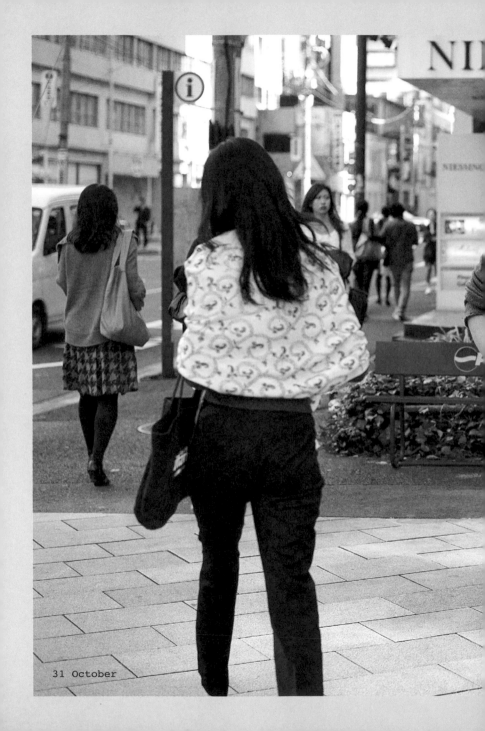

31 October

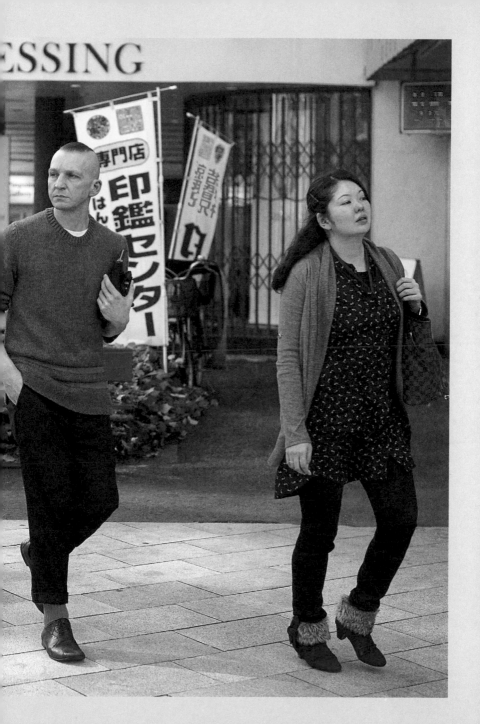

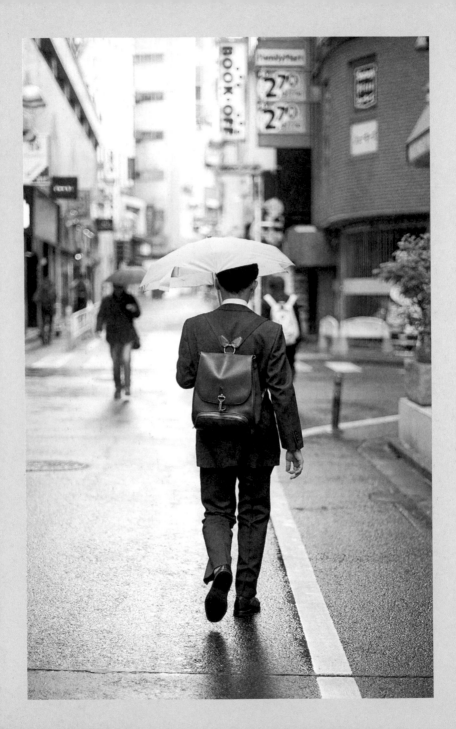

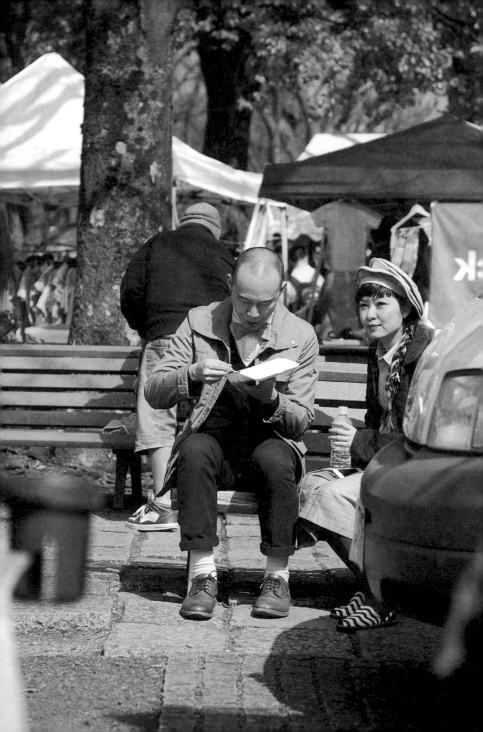

Japanese denim is rightfully known as the world's best. This man wears it with pride from head to toe.

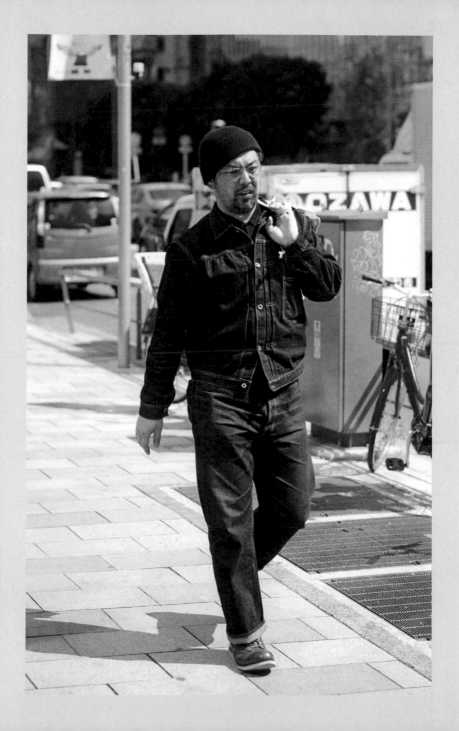

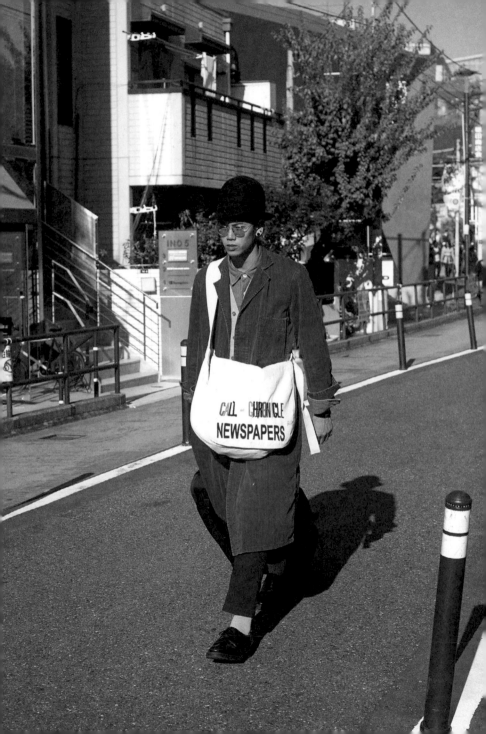

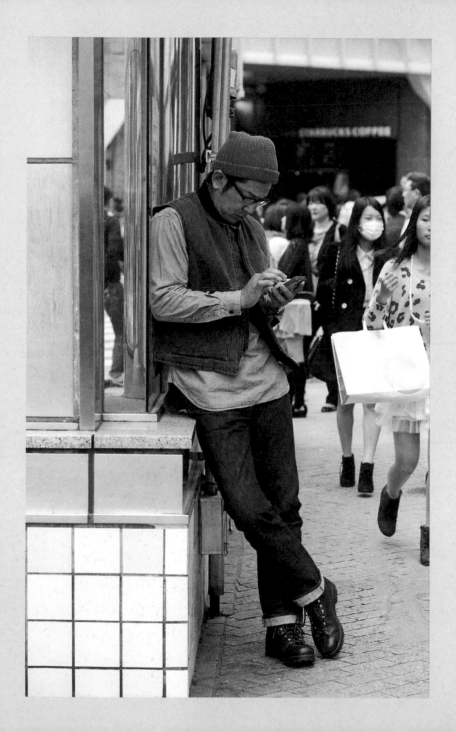

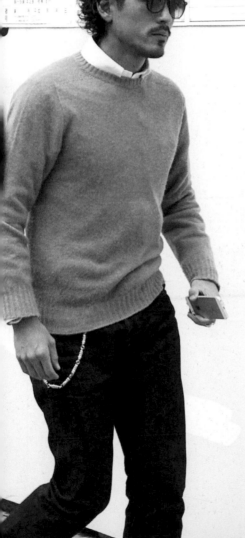

保険関係成立年月日　平成 25 年　2月
労働保険番号　13-1-04:836080
事業の期間　自　平成 25 年　2月
　　　　　　　至　平成 26 年　4月
事業主の住所氏名
注文者の氏名
事業主代理人の氏名

Mustard

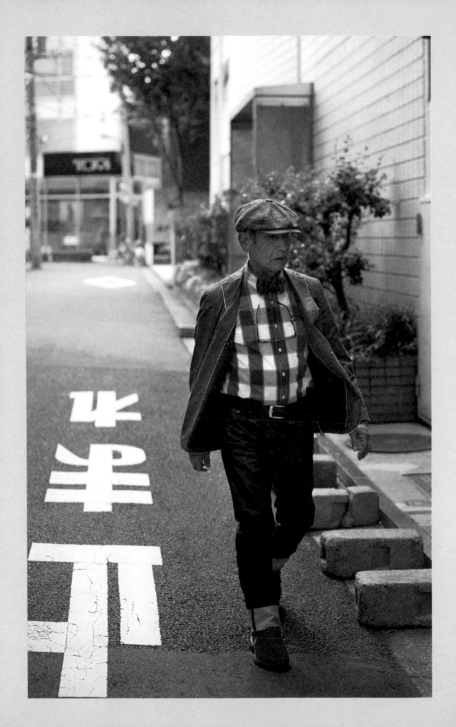

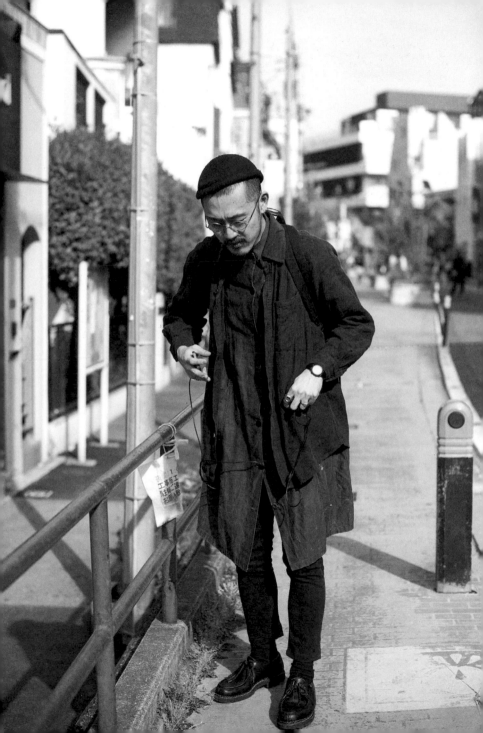

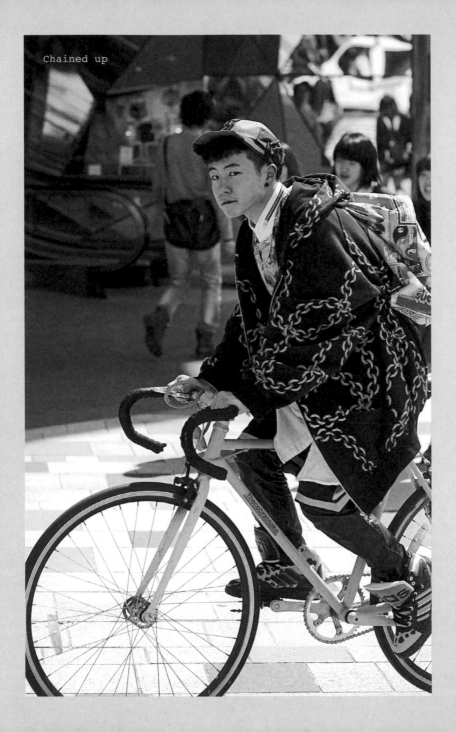

Chained up

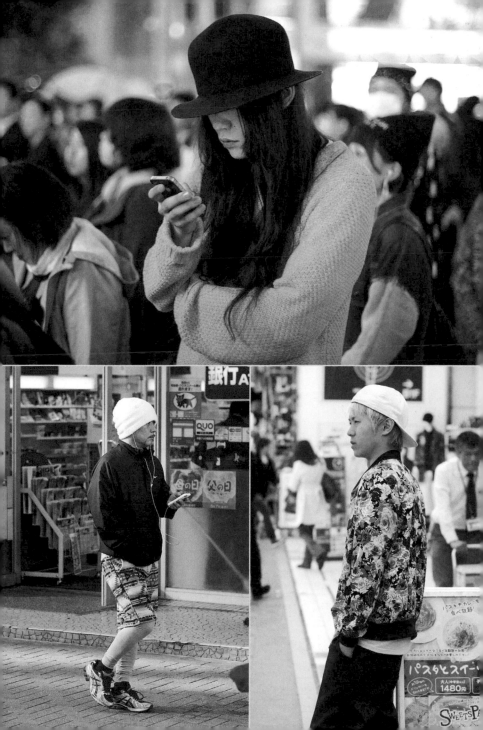

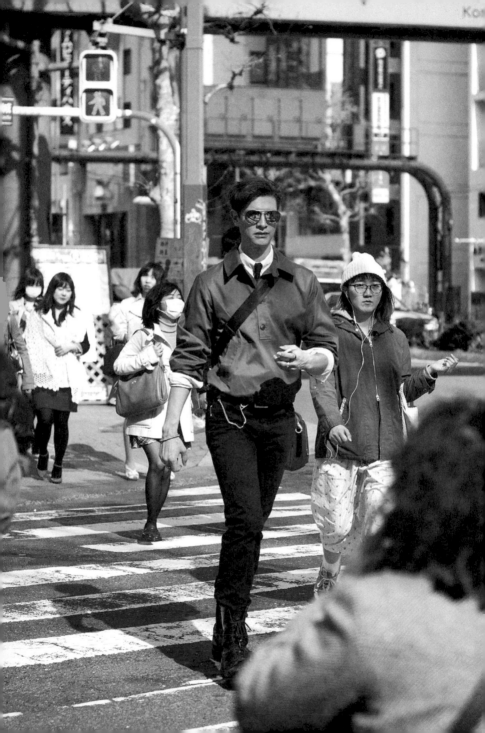

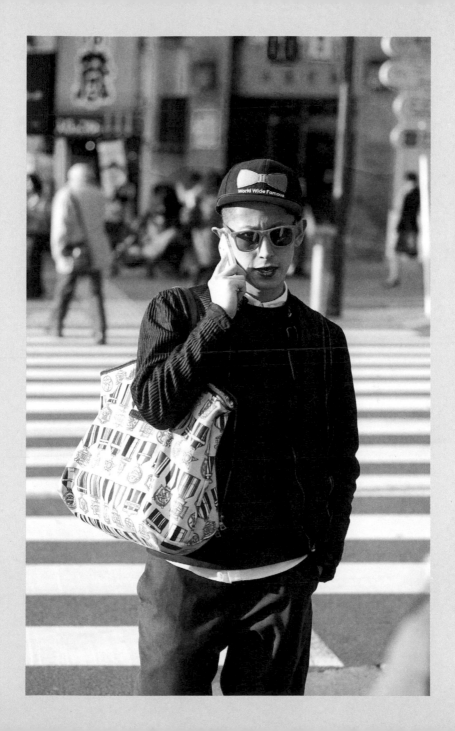

It's rare to see a city embrace its style heritage with as much respect as Tokyo. A traditional kimono captured on a busy street corner of Shibuya.

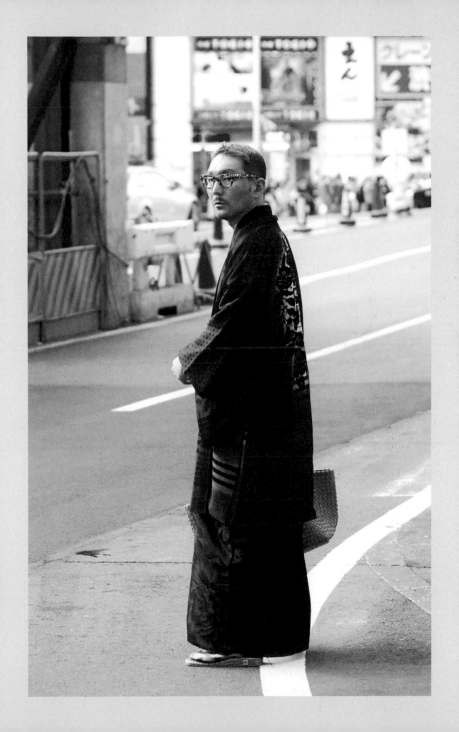

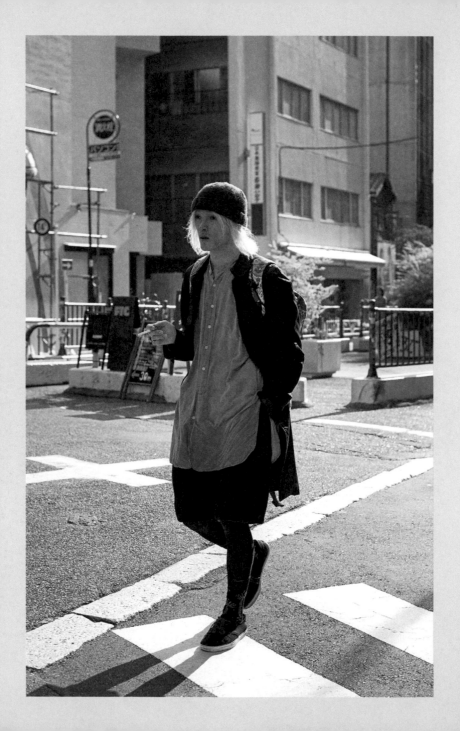

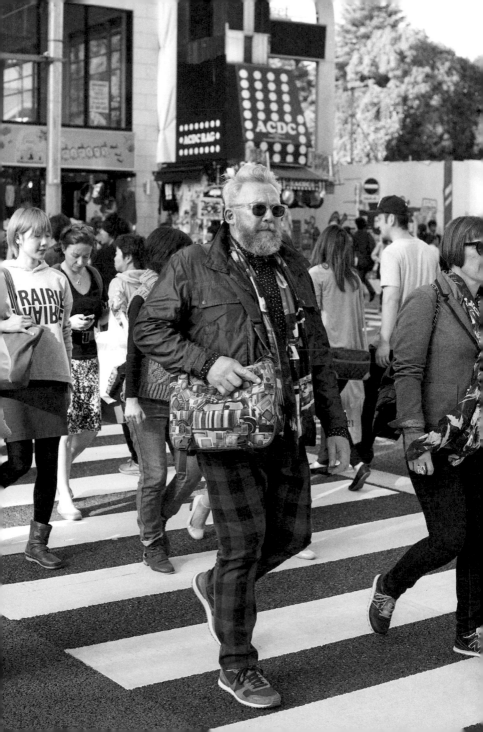

TOWN

Sydney

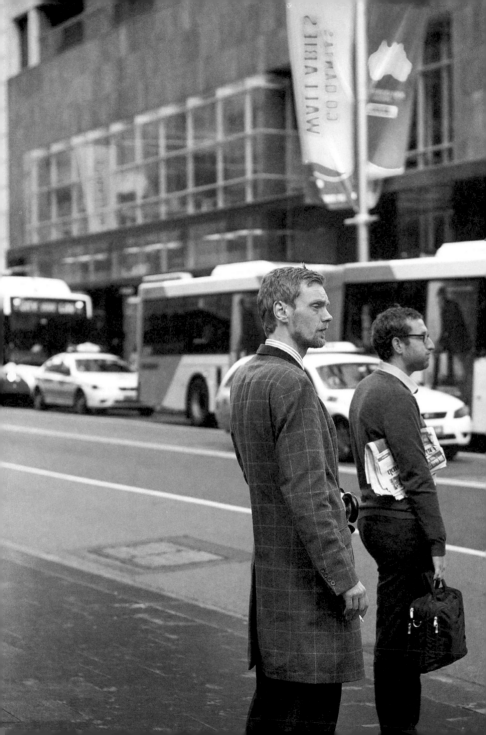

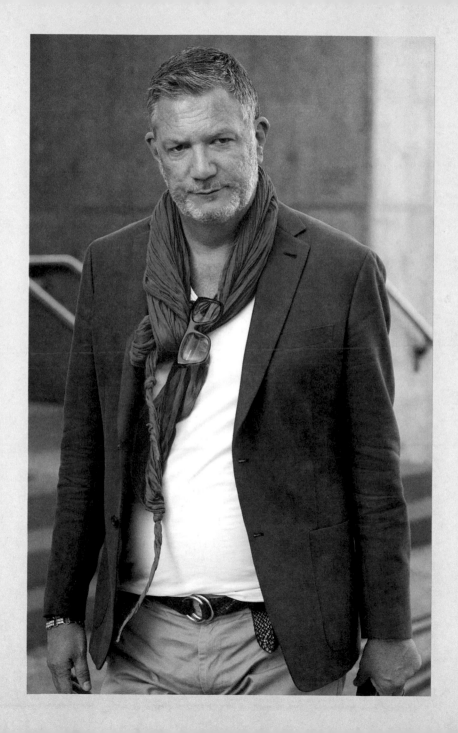

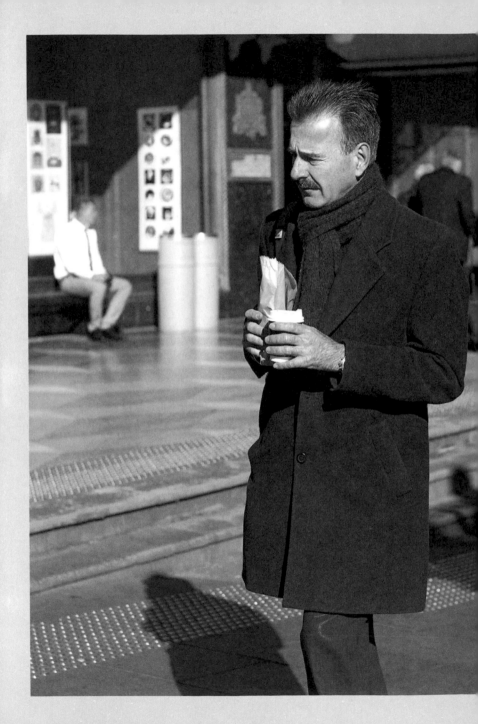

Parisian effect

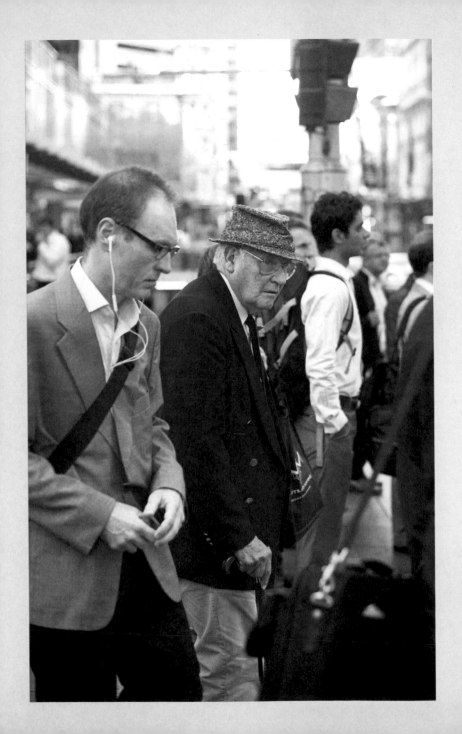

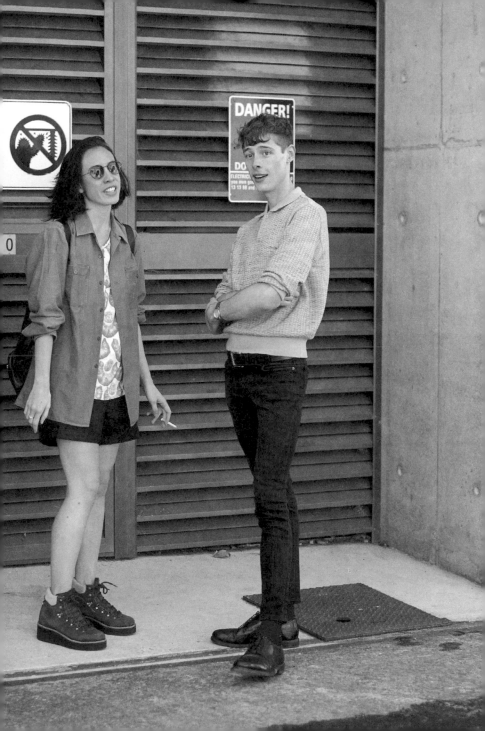

Permanent pattern at Carriageworks during Sydney Fashion Week. His commitment to the look is commendable.

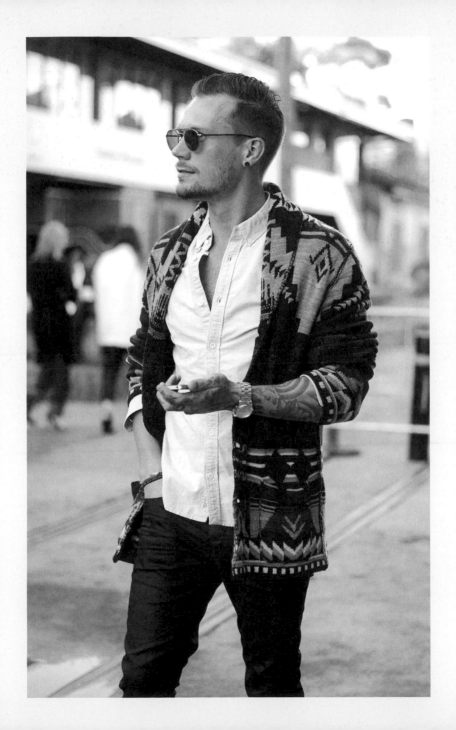

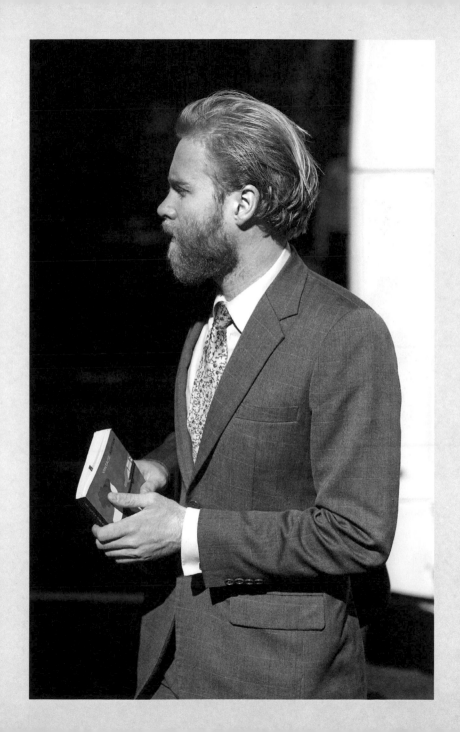

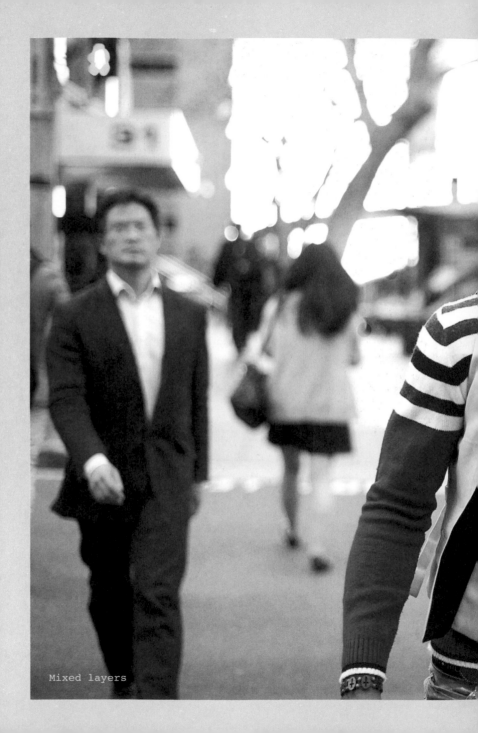
Mixed layers

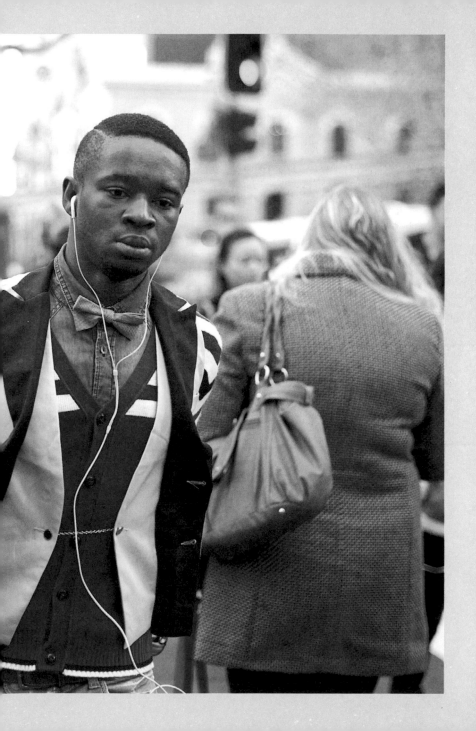

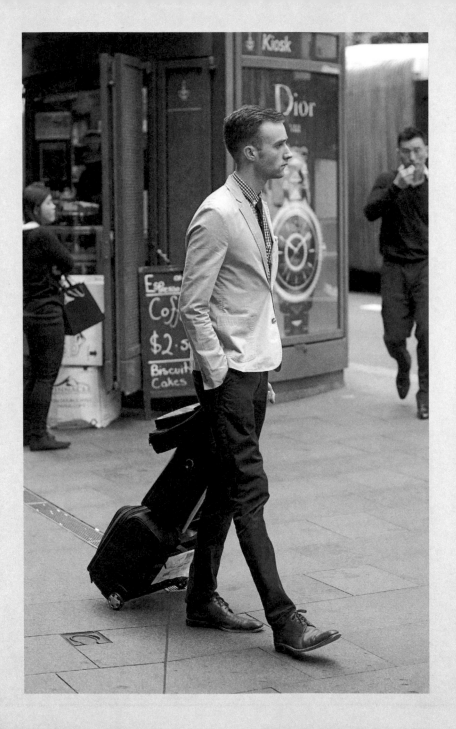

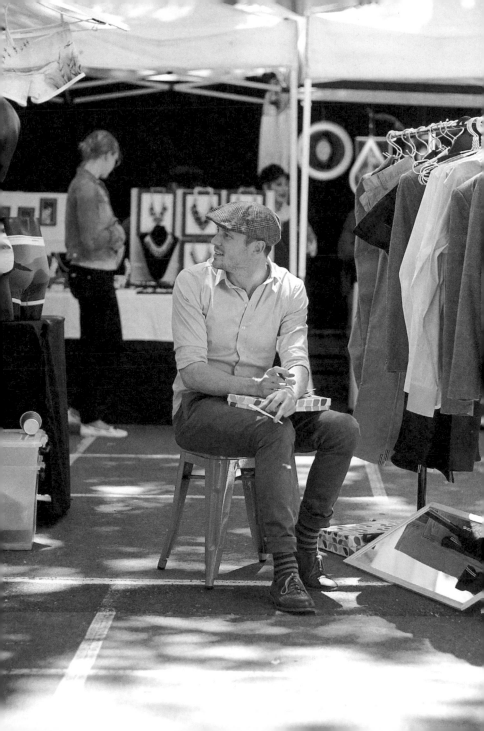

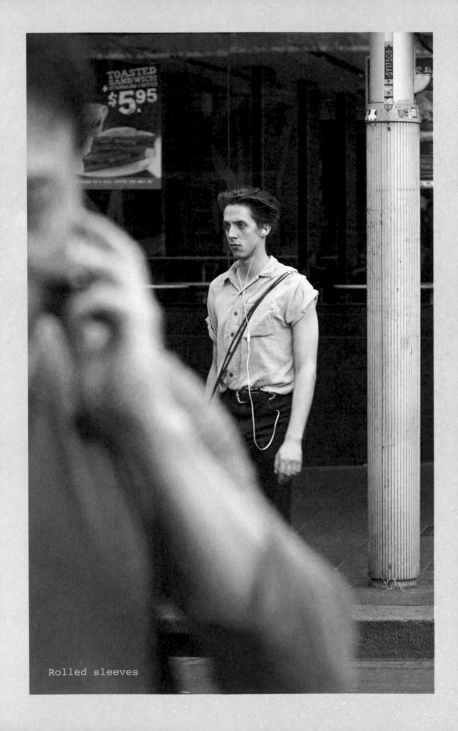

Rolled sleeves

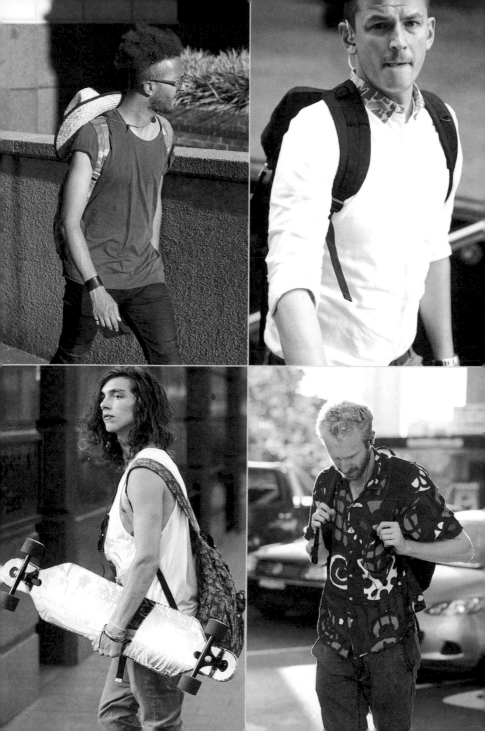

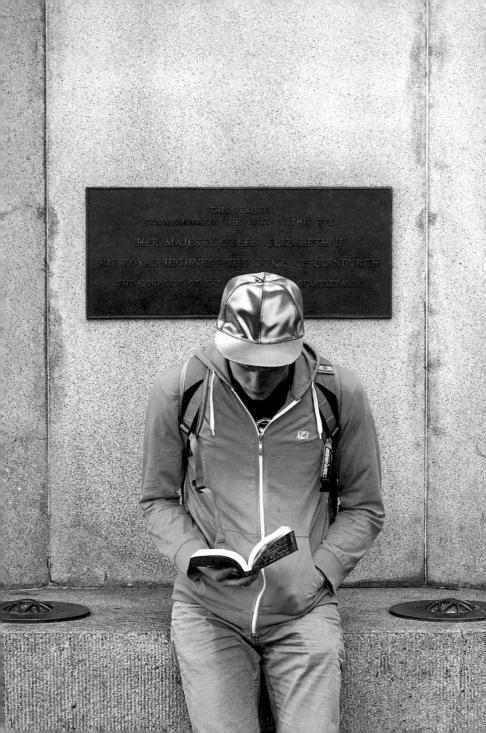

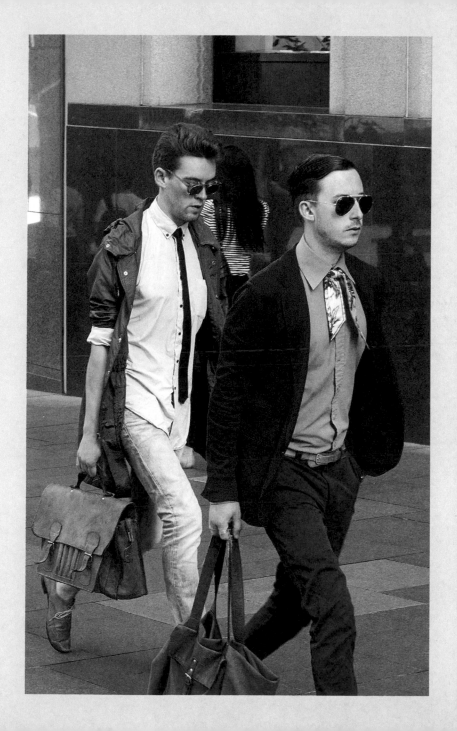

Angel wings

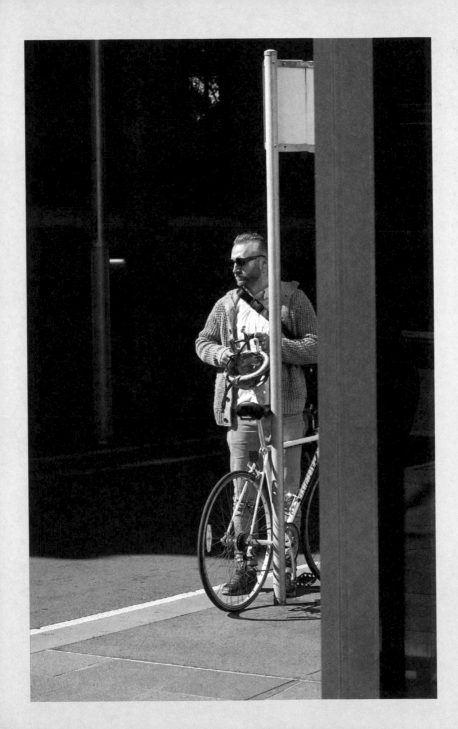

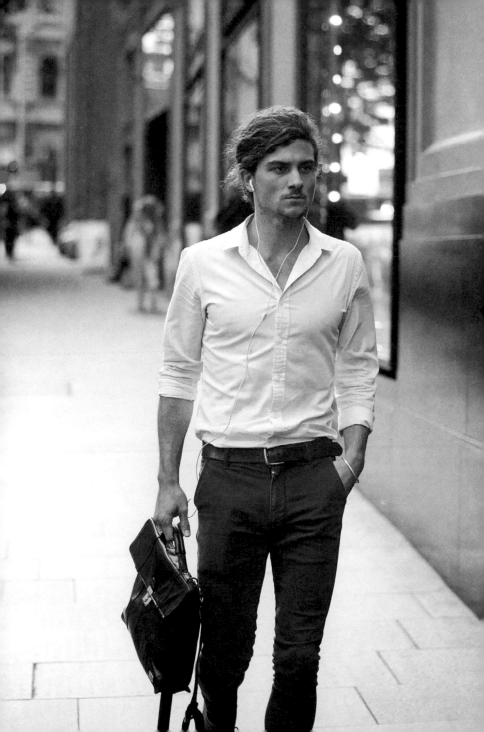

Patrick Johnson in *Sydney*

One of the first men I profiled on *men in this town*, Patrick really inspired the idea of knowing the man behind the clothes. As an innovative tailor based in Paddington, he's suiting up Aussie men, one bloke at a time.

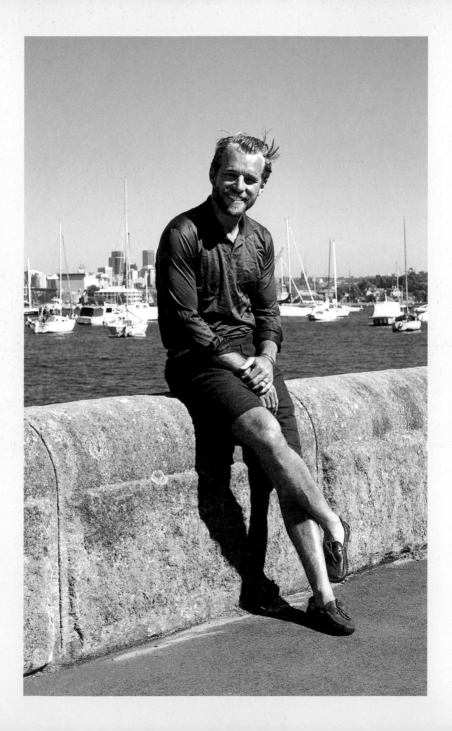

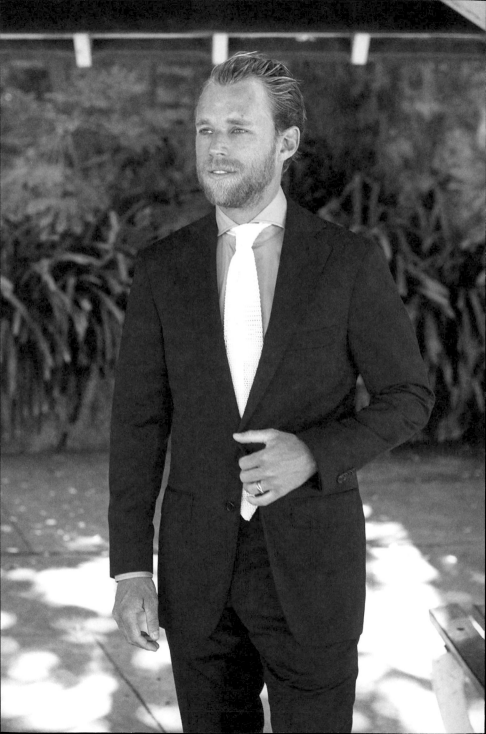

On his personal style

It's constantly evolving, sporty, classic with a focus on comfort. I am not too keen on bold, distracting patterns – I like a more subtle approach. I dress for now and the future, without looking to the past too much. At the end of the day, I dress for me.

On his style progression

I was a kid from South Australia who was into dirt bikes, pretty much a bogan I suppose. Pretty messy. Most nights when we had dinner we had to wear a jacket and all that kind of stuff. But during the day it would be jeans and a T-shirt.

As I got older and went through school and university I started dressing more smartly and experimenting with colour and classic tailoring.

I used to go to second-hand stores to buy suits and get my local tailor to alter them. I built a wardrobe that way; it's a perfect place to start. You don't have to have 50 or 60 suits in your wardrobe. You can do it very well with one or two and a pair of jeans.

On his interest in fashion

You have to wear clothes every day, so you start thinking of it from that point of view. I grew up in a household where my stepdad was really into his suits and that sparked my interest.

He used to and still does dress very well, in an English way. We lived in the country, so he wore a lot of tweed, which is ridiculous in the South Australian countryside, but he was quite into it. Hunting outfits and stuff like that.

In his day-to-day dress, he's a very elegant man. I remember his incredible dressing room that I used to sneak into. He would never let me in but he had some amazing stuff.

On dressing your age

Most older Australian men dress like kids, so maybe the younger men should dress like adults. I think it's great. There's no right or wrong, it's all about experimenting. I think there's a big difference between dressing up and playing dress-up. As long as men are trying to find their own tastes or styles, I think it's healthy. Finding your own style takes ages, it's no wonder that most of the best-dressed men are in their sixties.

On dressing in Australia

I think it's an interesting time in Australia. Up until recently, men didn't put much thought into how they dressed. Our style came from the English tradition but that didn't lend itself to Sydney because of the climate. Our climate is more similar to Naples and I think our clothing choices are starting to reflect an Italian sensibility.

We're dressing in a sportier way, wearing lightweight fabrics, wearing casual suits more effectively. A lot of my clients are incredibly practical. They'll wear a lovely navy-blue suit but will have a light, unstructured jacket. We're seeing more polo shirts with suits, and even running shoes. It's perfect for Sydney. Anything to keep things lighter and more breathable.

You don't see ties that much anymore. Men are finding other ways to accessorise their looks. They'll put more focus on a shoe or a bracelet or a pocket square.

Light also plays a big factor. I've just been abroad and it's winter time in Italy. You see all these great muted tones but they would never work in Australia. You need something with a little more punch.

Understated elegance is the goal.

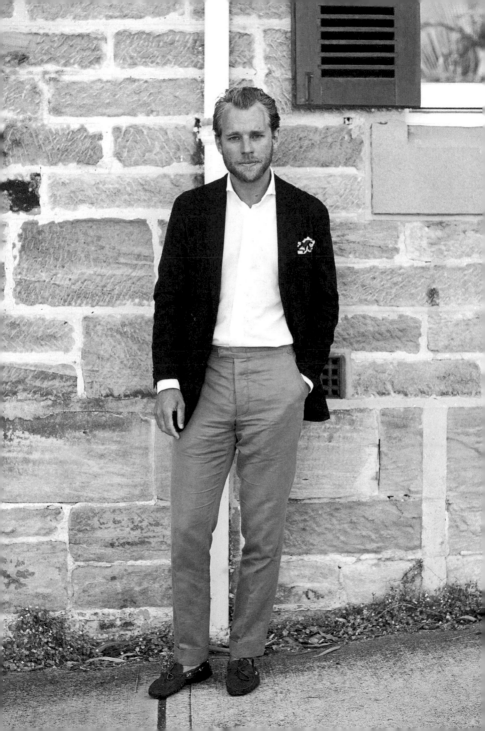

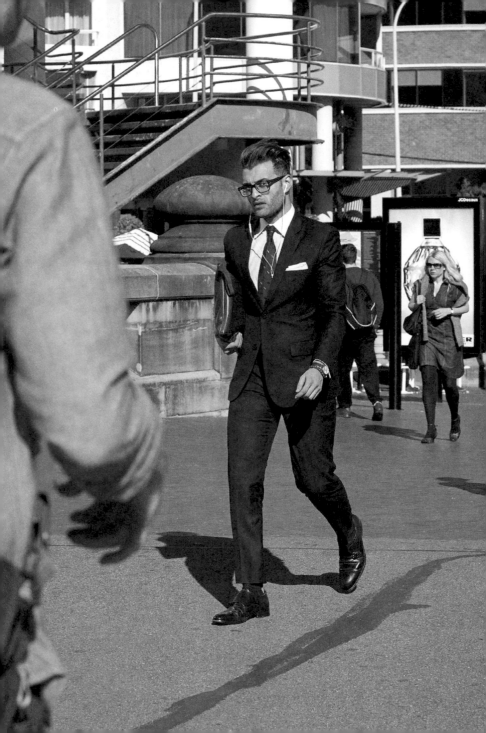

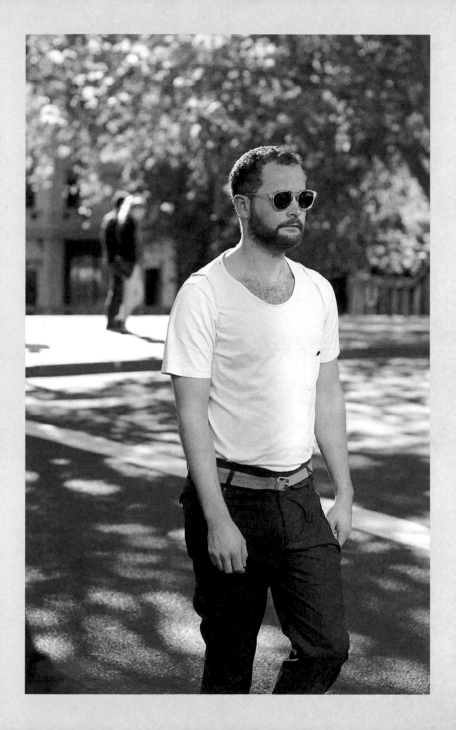

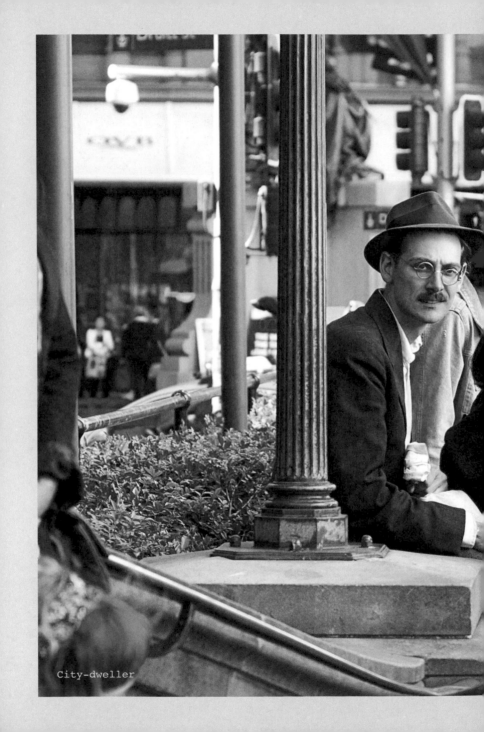
City-dweller

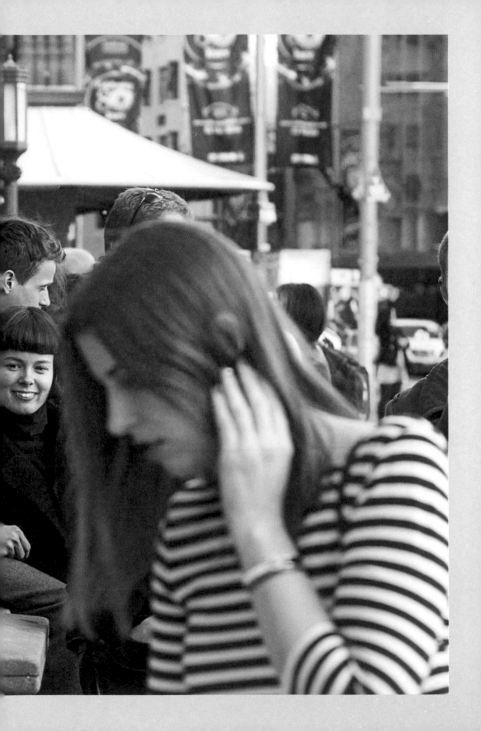

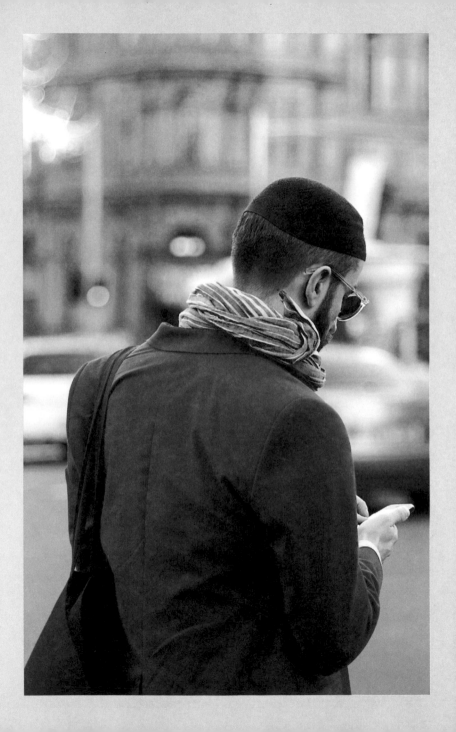

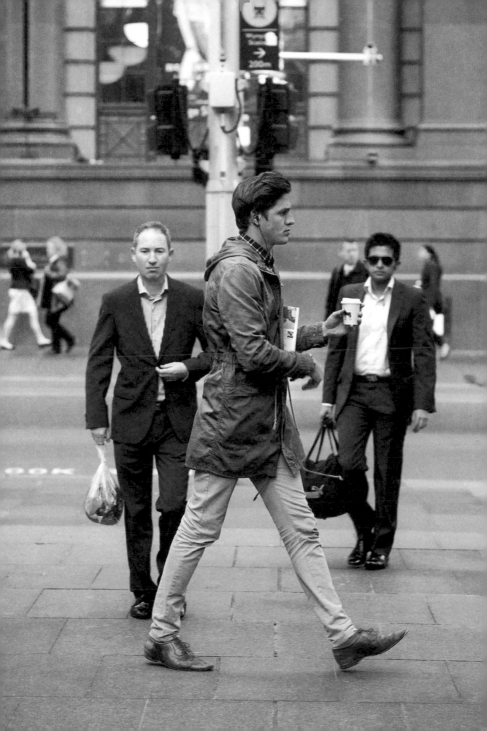

Green with envy. Never a shortage of characters on George Street.

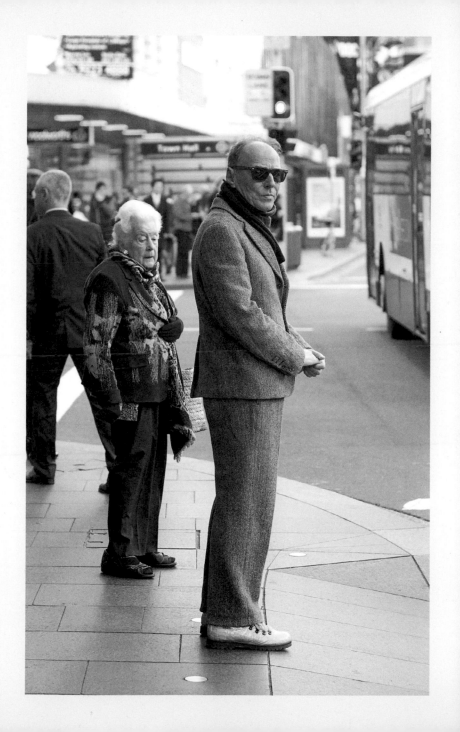

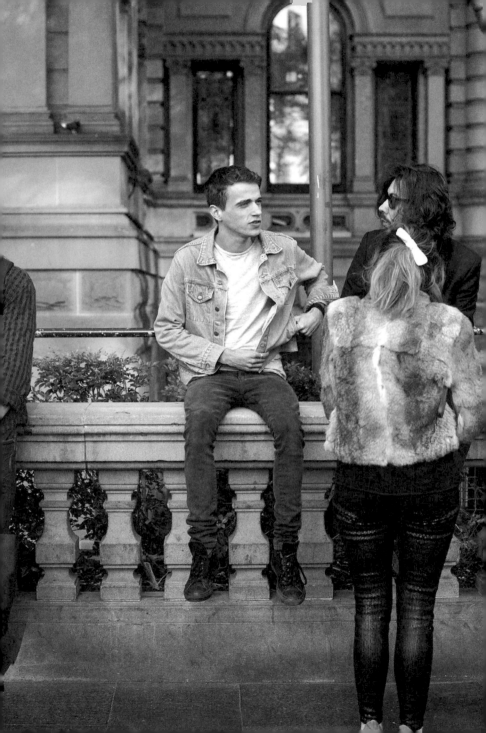

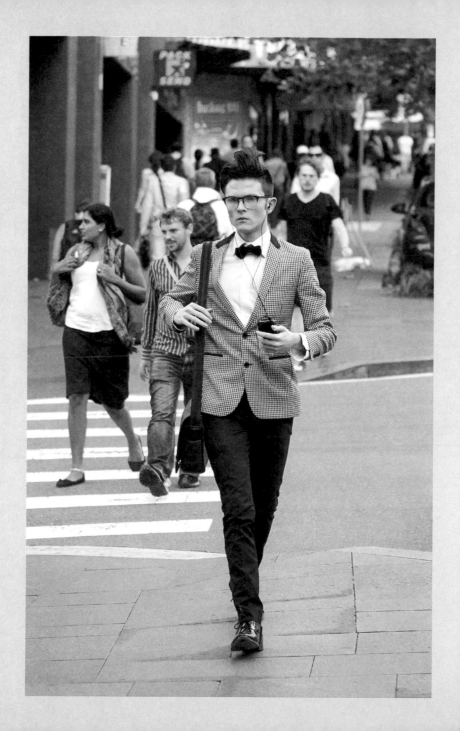

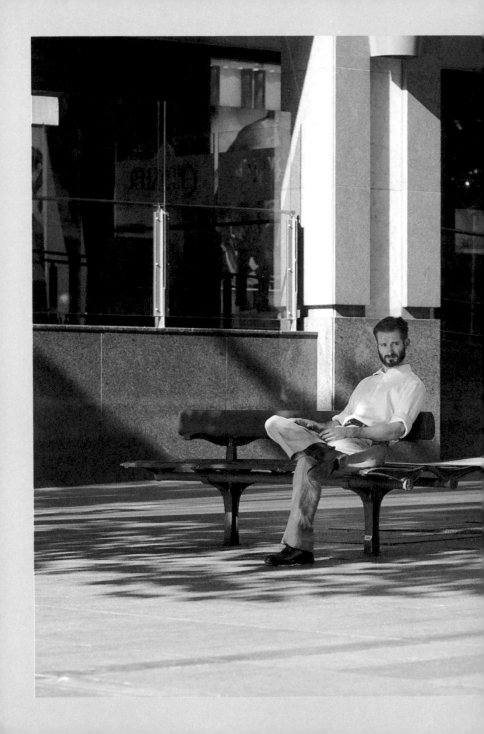

Solo

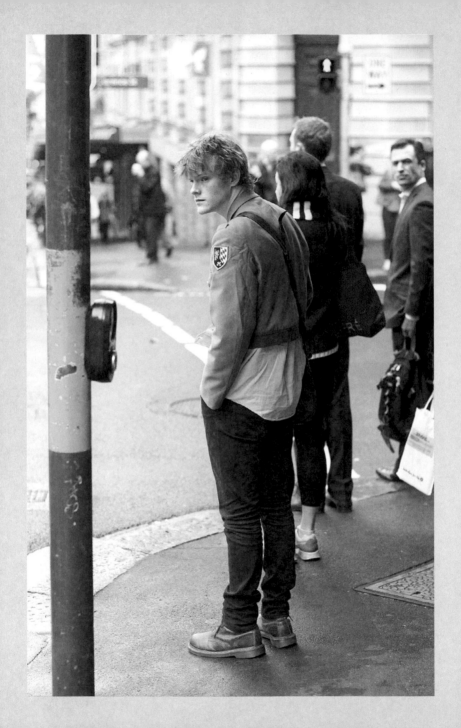

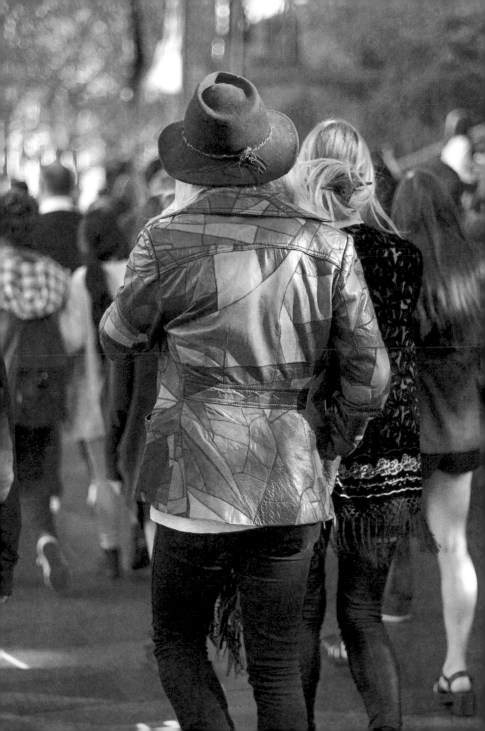

ST JAMES STATION

CHÂTEAU

Work cycle

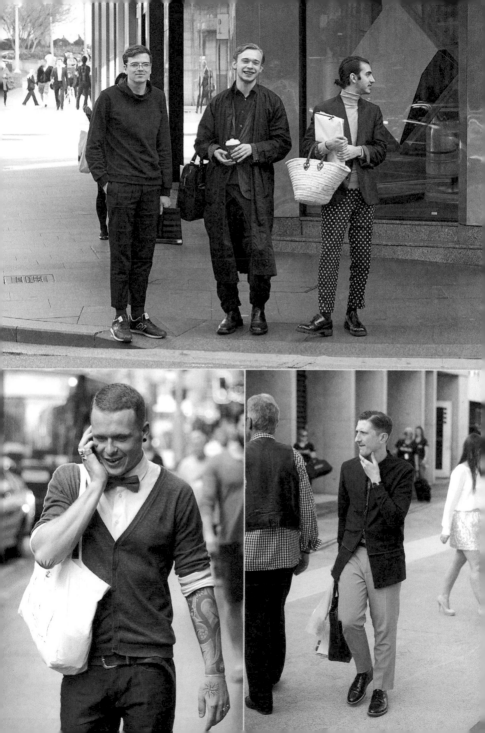

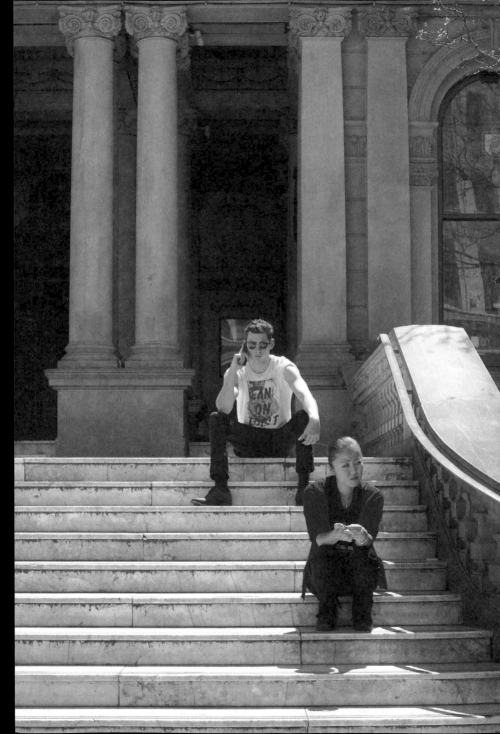

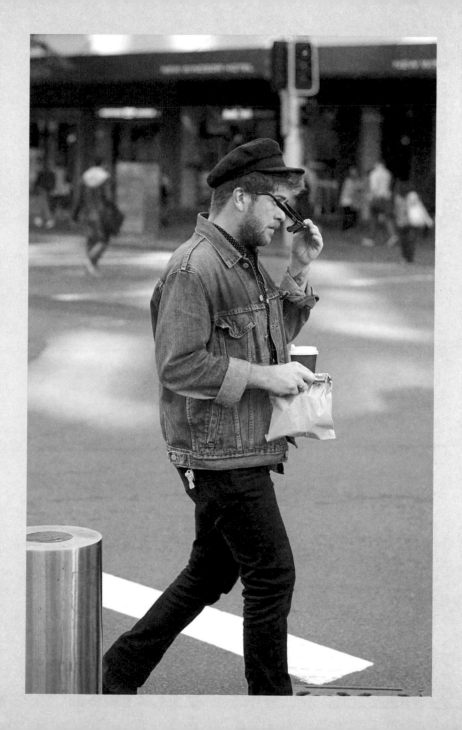

NOTES

Sometimes it's about the effortlessness and ease with which garments fall together.

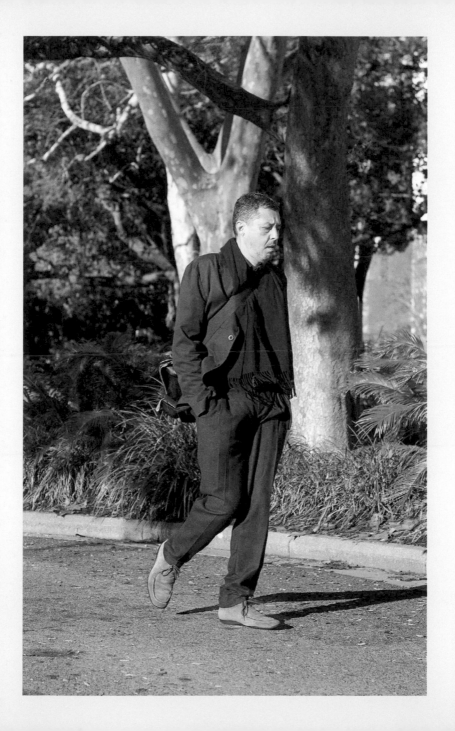

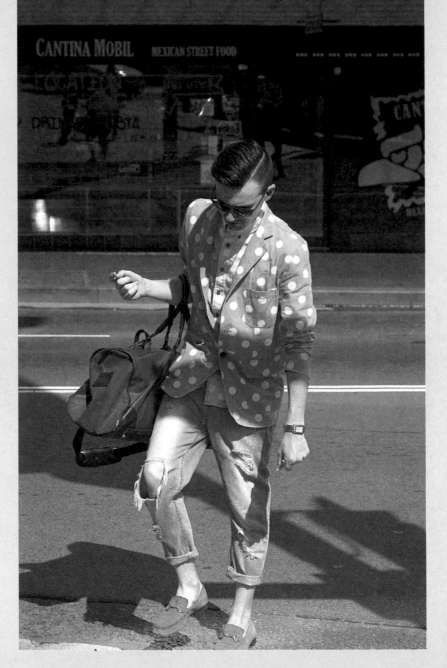

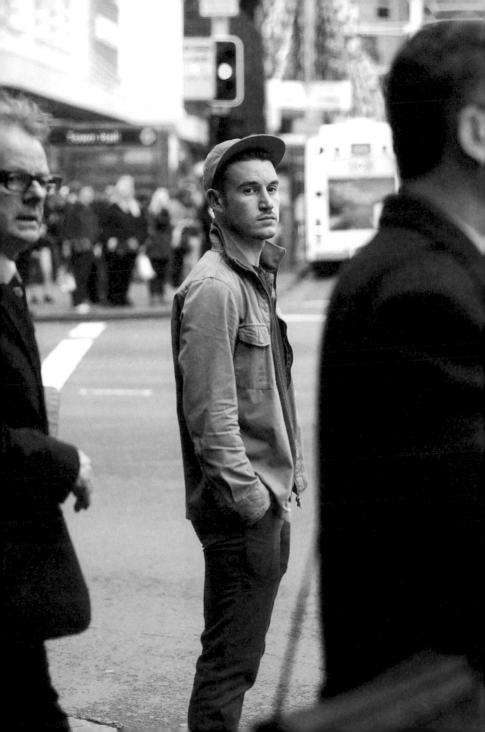

Milan

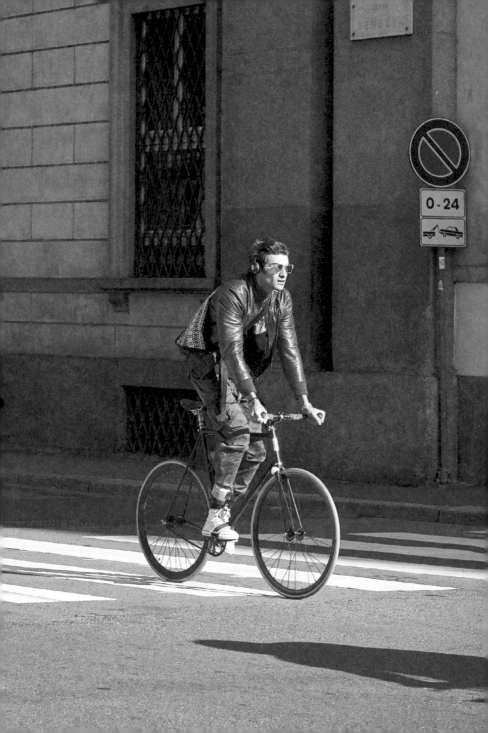

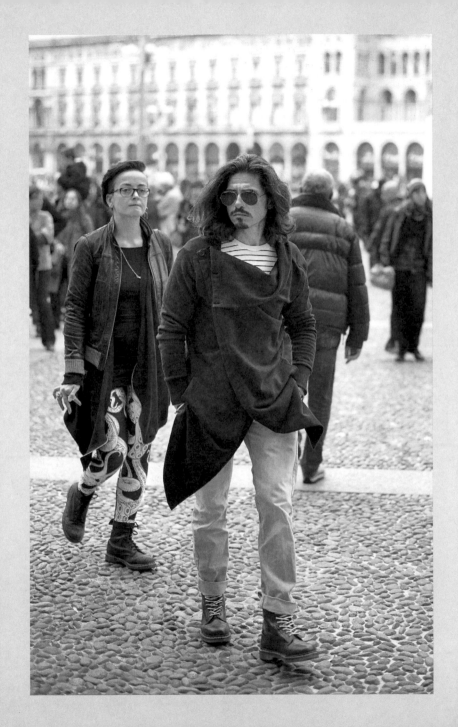

Beret in Milan

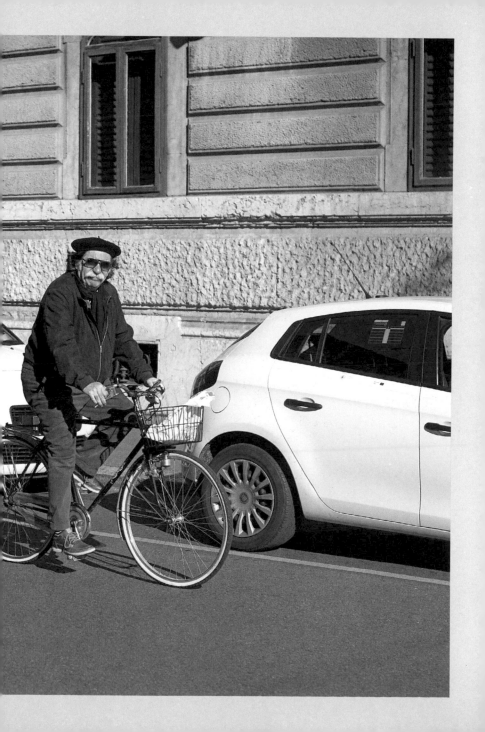

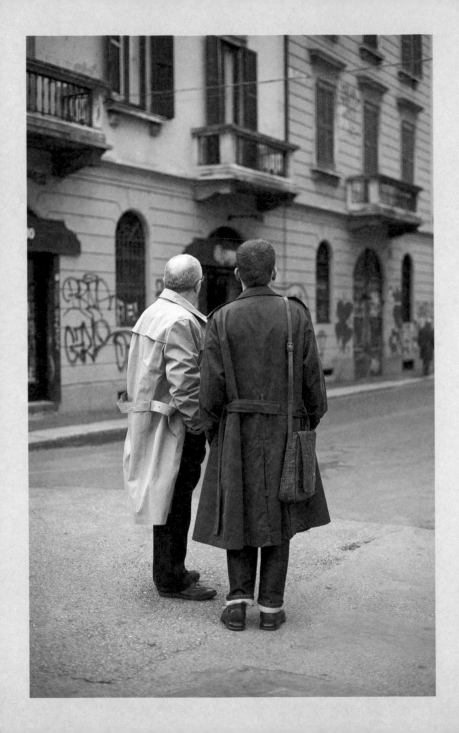

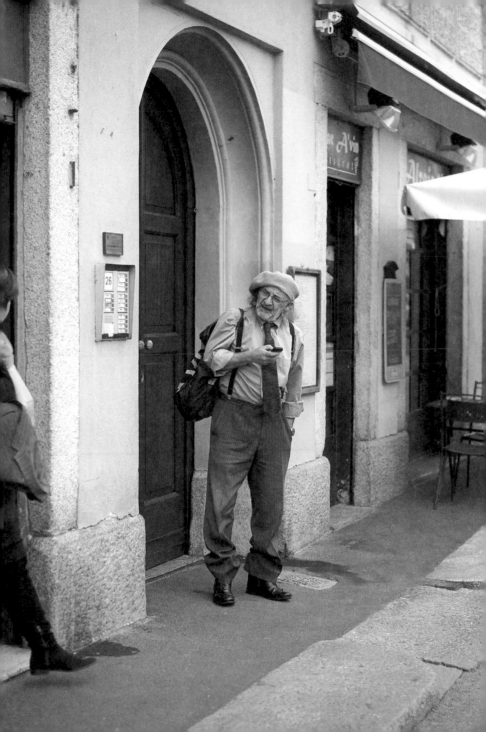

NOTES

The graffiti-covered Corso Buenos Aires creates the perfect contrast to this man's polished look.

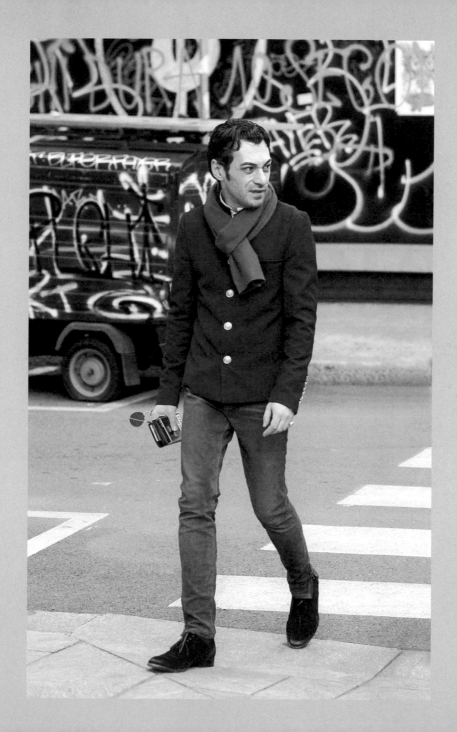

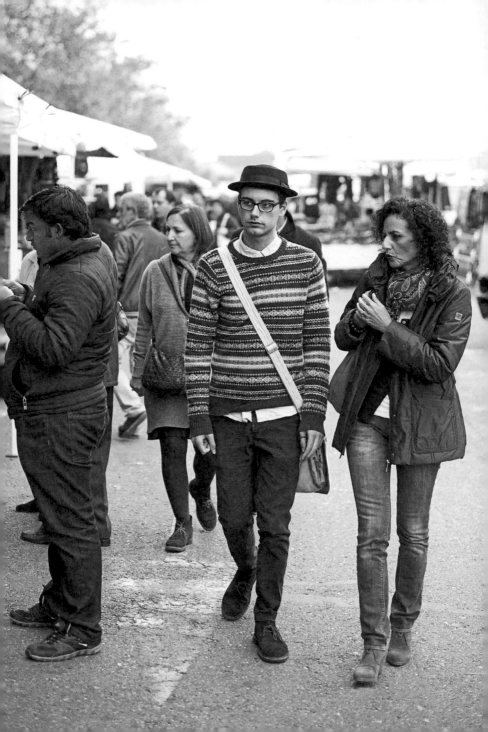

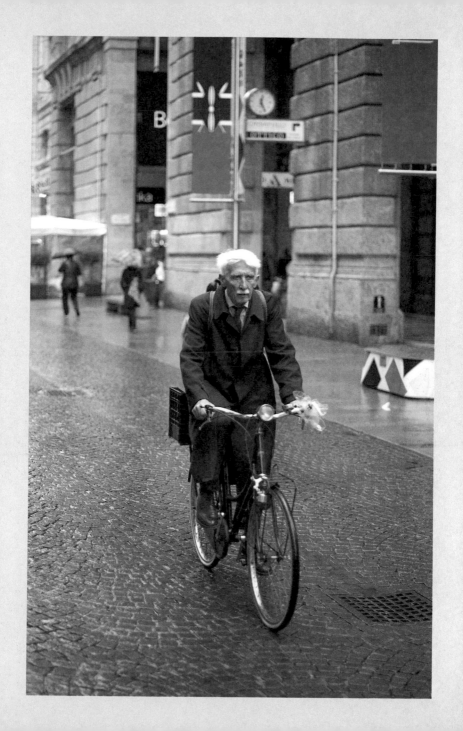

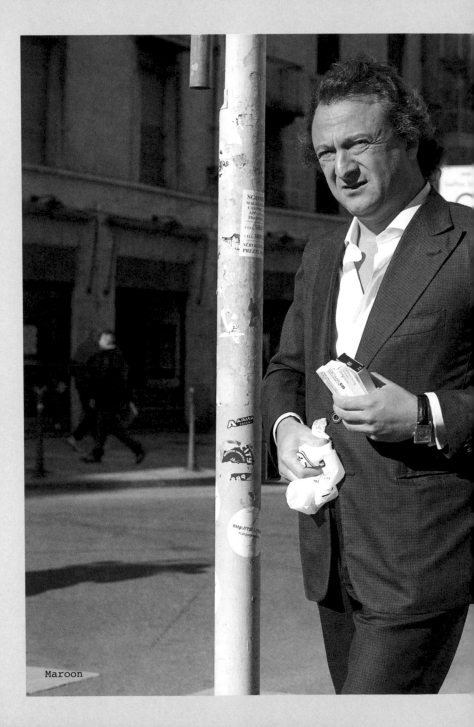

Maroon

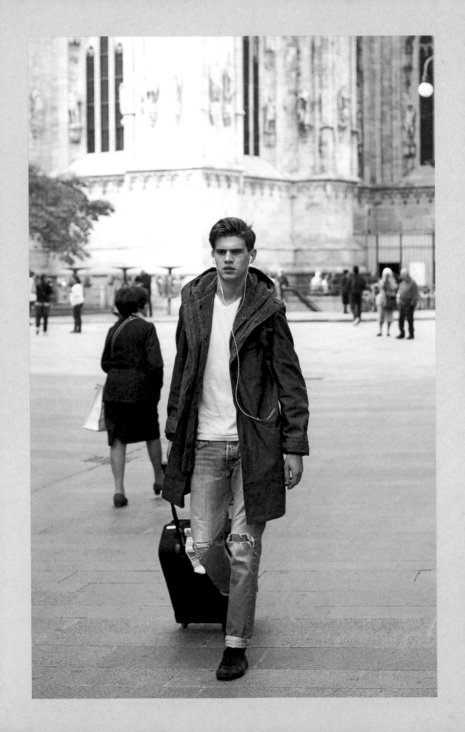

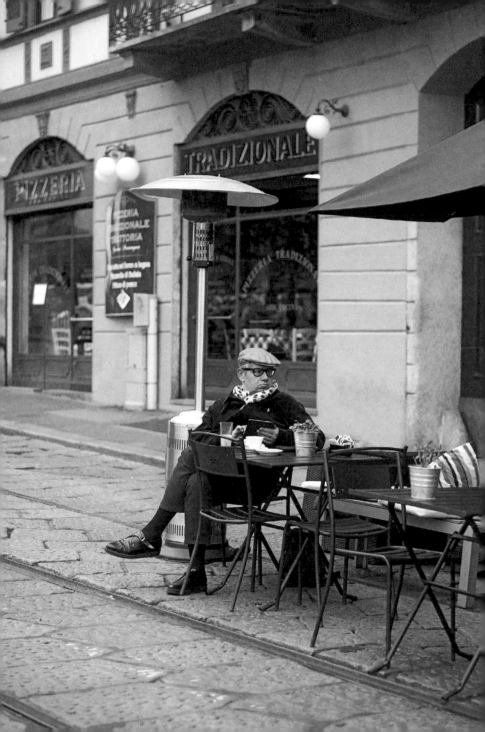

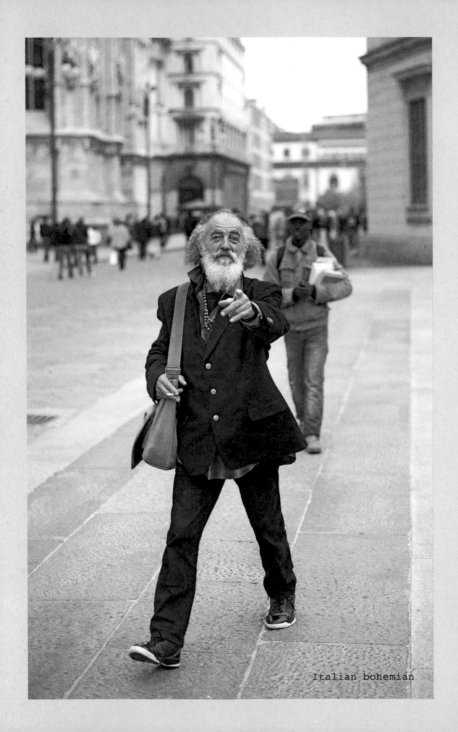

Italian bohemian

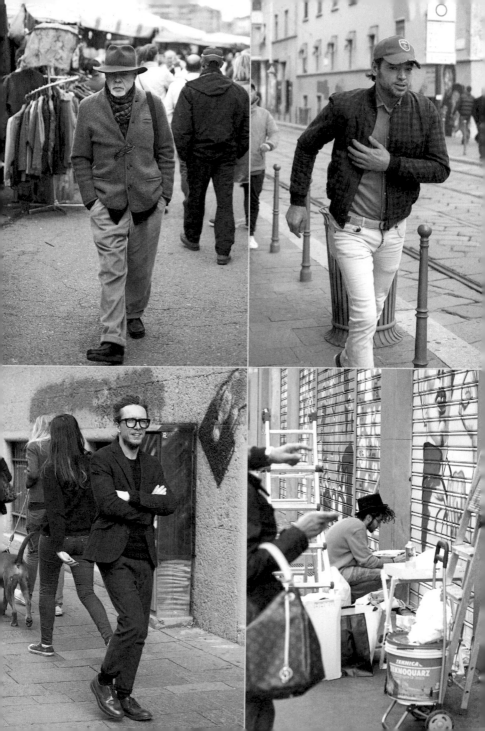

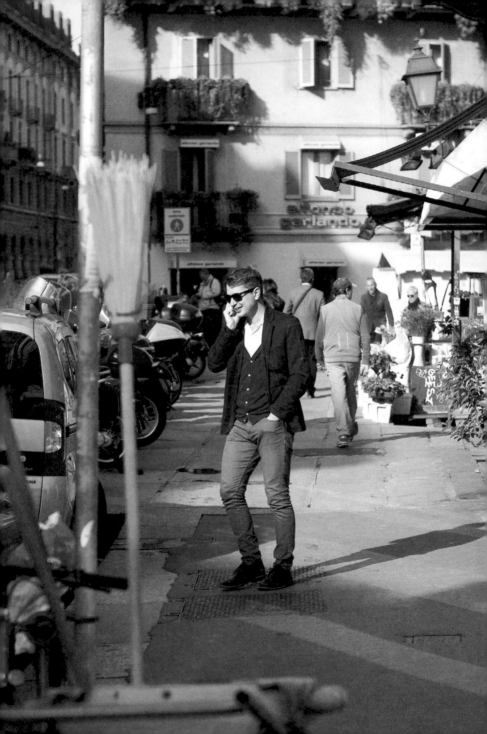

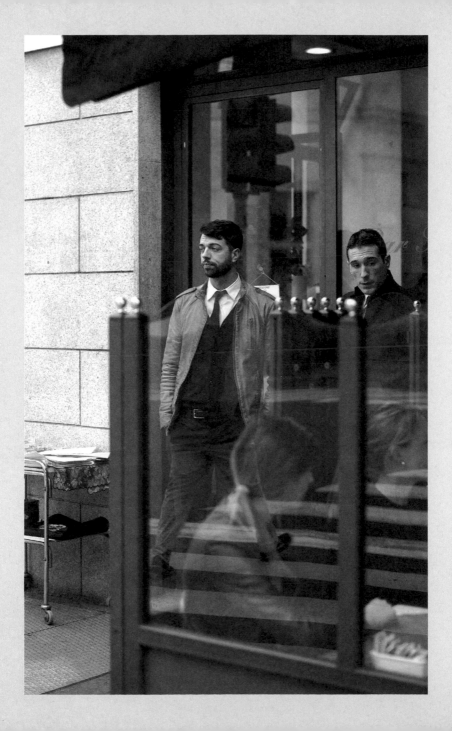

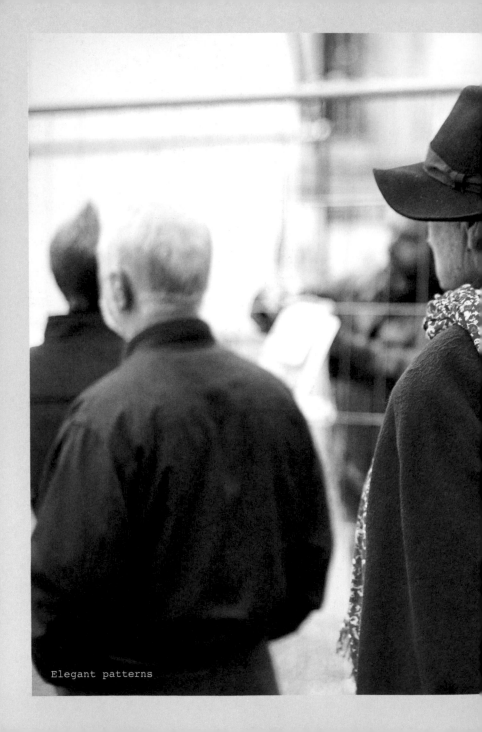
Elegant patterns

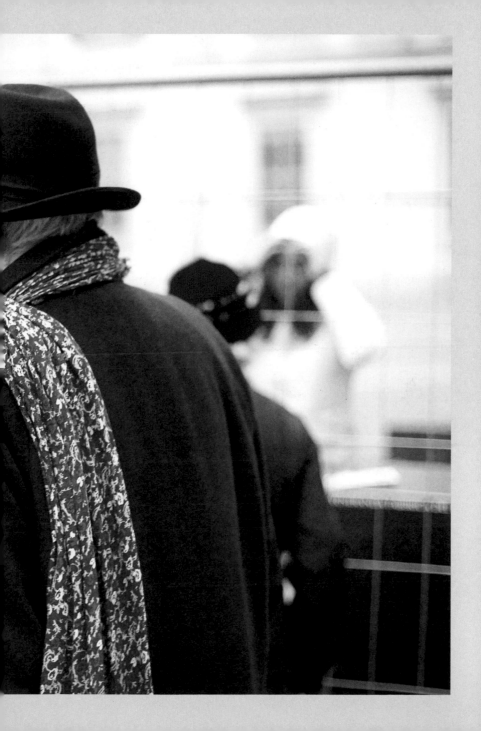

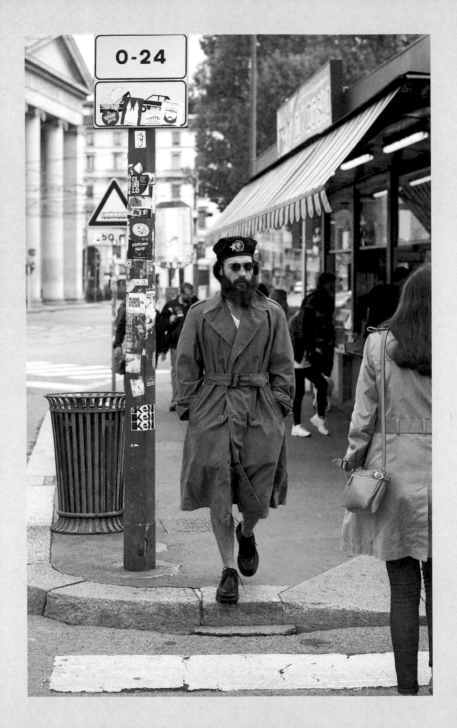

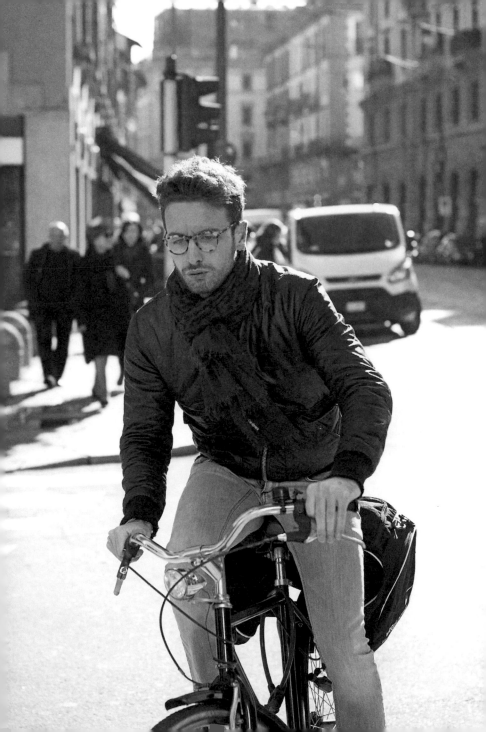

Alessandro Squarzi in *Milan*

An influential man in the Italian fashion industry, Alessandro Squarzi uses his garment showroom to display Italy's best to the world. Having worked his way to the top as a young man, Alessandro's passion for all things menswear is contagious, as I learned when I met him at his home in central Milan.

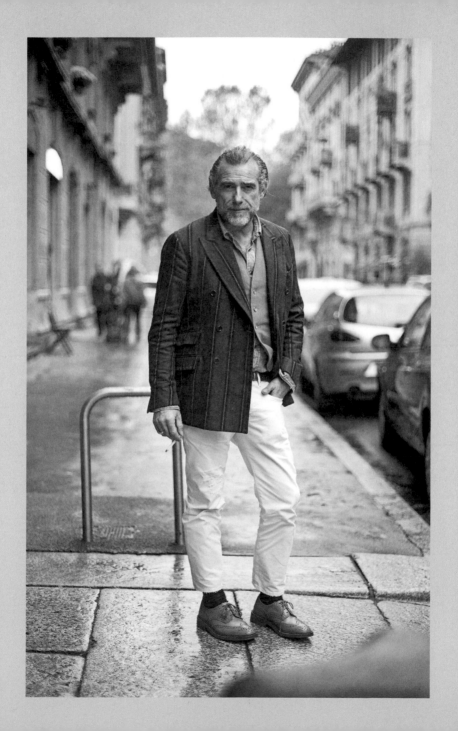

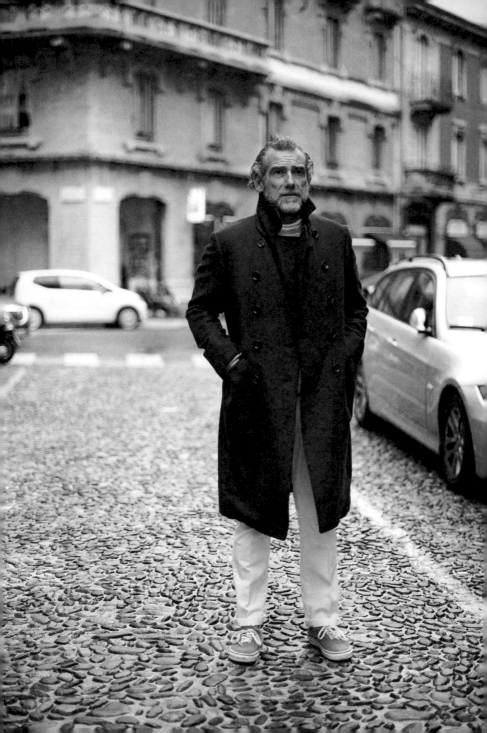

On his personal style
Classic globetrotter.

The way I dress comes naturally to me. I don't think you need to overdo it. I dress according to my body and don't focus too much on what is 'trendy' at the moment.

When I wake up, I check my wardrobe, and what I put on reflects how I'm feeling that morning. I have all the essentials so it's easy to work with.

On his style progression
Generally, my style hasn't changed much. White pants are something I've always worn. I started wearing jackets as I got older but always just did my own thing.

Although I work in the fashion industry, I've never felt the need to follow trends. I've always had my own thoughts on what fashion is and how it looks best on me.

At 23 years old, I had my own Harley-Davidson, which at the time was not very common or cool. I always went against the grain. People would put a scarf on, I would put on a hat.

When you're young, you should express yourself and dress the way you feel. It shouldn't be trivial. I'm older now but I still like to have fun with my clothes. Only to a certain point – not so that they look ridiculous.

On his interest in fashion
I feel like I was born with a sense of style. The men I was surrounded by, growing up, were always impeccably dressed and it became second nature to me. When I was a young man, I was given the opportunity to work in the fashion industry in a retail position and I took it. This gave me the chance to further my knowledge.

On Italian style
I wouldn't single out how men in Milan dress but how Italian men dress as a whole. Milan is a business city;

there are more men in suits and ties here than anywhere else in Italy. It's formal and conservative. Rome is more casual and fun. In Naples people dress very well. It's a very creative city.

You can't find the fashion sense that Italian men have anywhere else in the world. Federico Fellini would be a beautiful example as well as Marcello Mastroianni. They have a timeless look that continues to be a source of inspiration for the younger generation.

Our sense of fashion is like our sense of taste. We need to eat, but we want to enjoy our food. We don't eat just because we're hungry. We all need to dress, so we like to dress well.

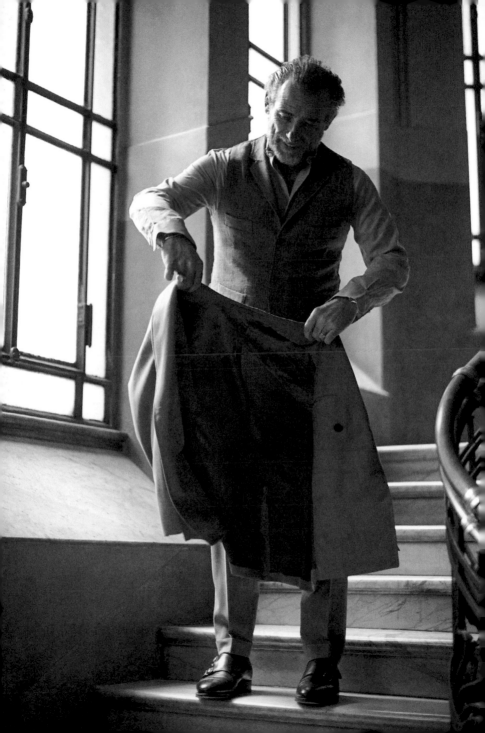

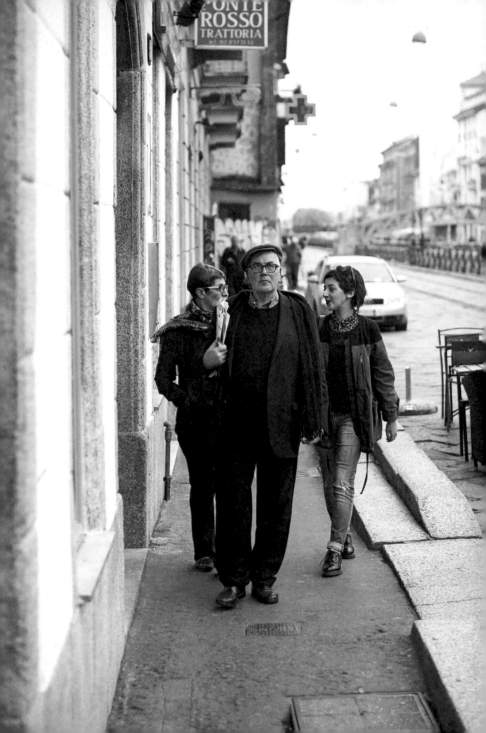

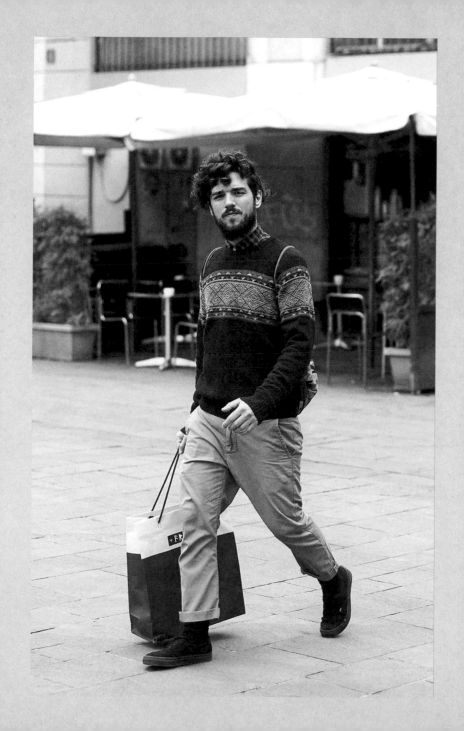

Man and his umbrella

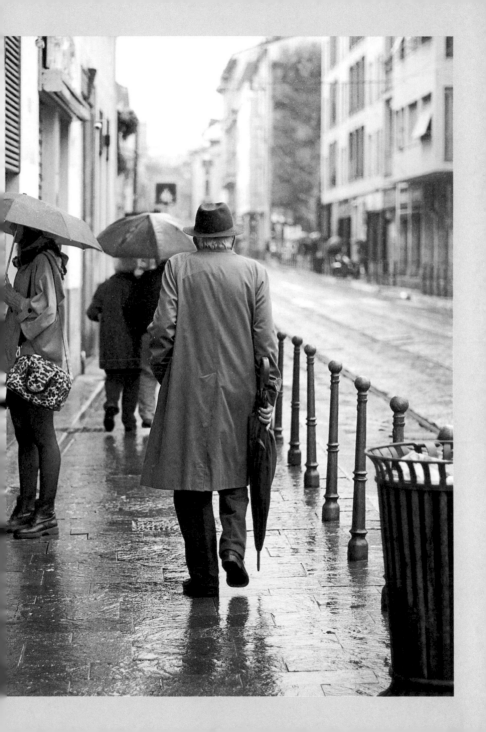

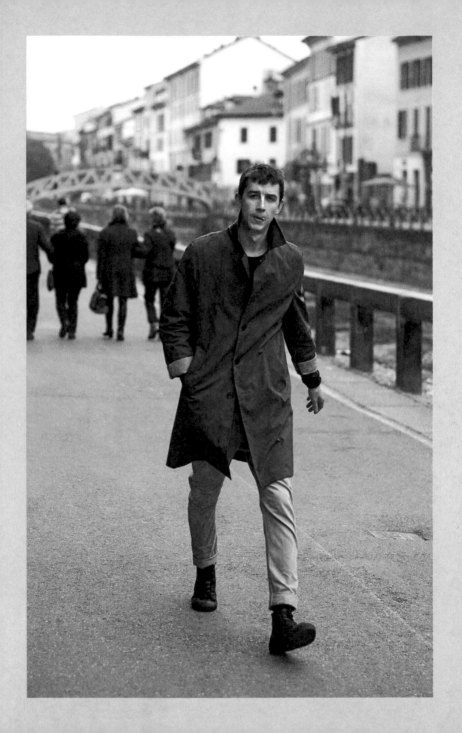

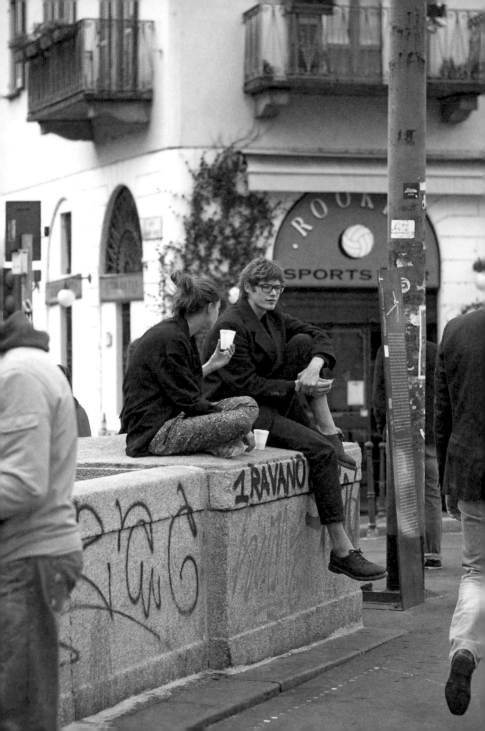

NOTES

Of all the men I shot in Milan, he stood out the most. Always refreshing to see someone break the mould in a town known for its traditional style.

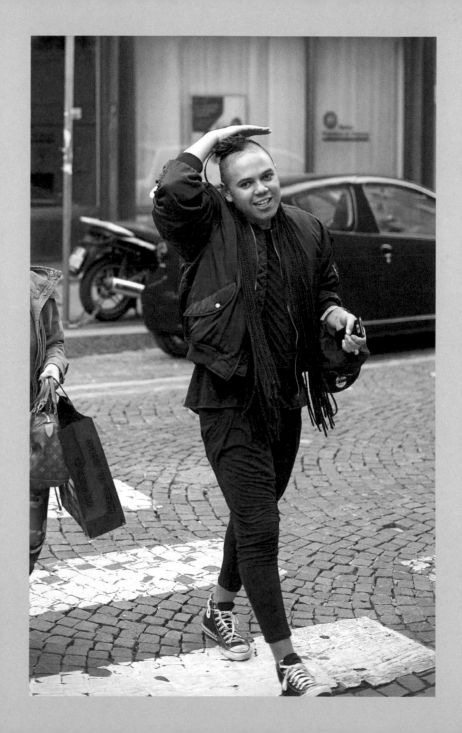

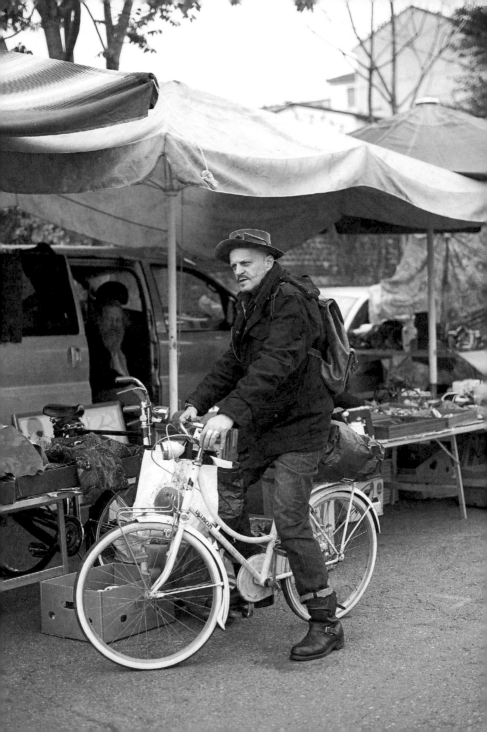

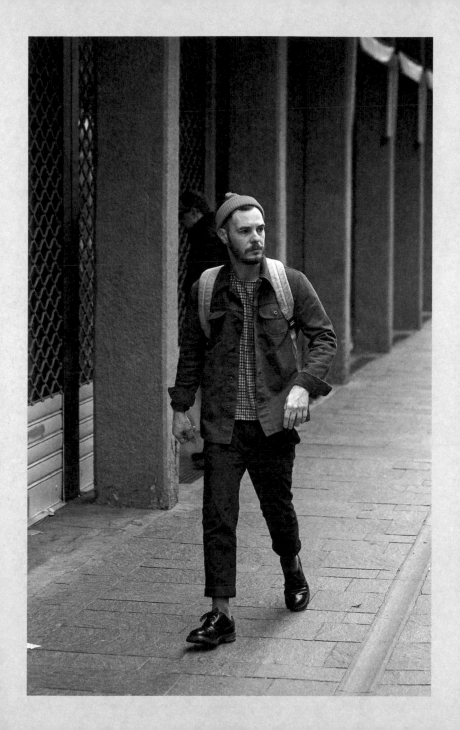

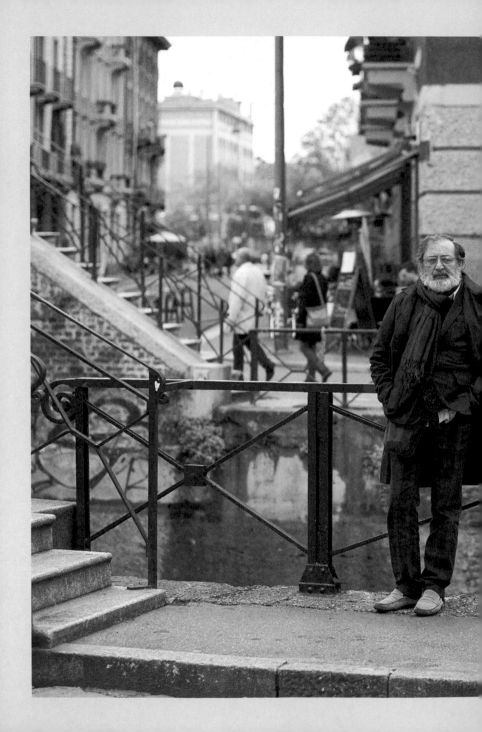

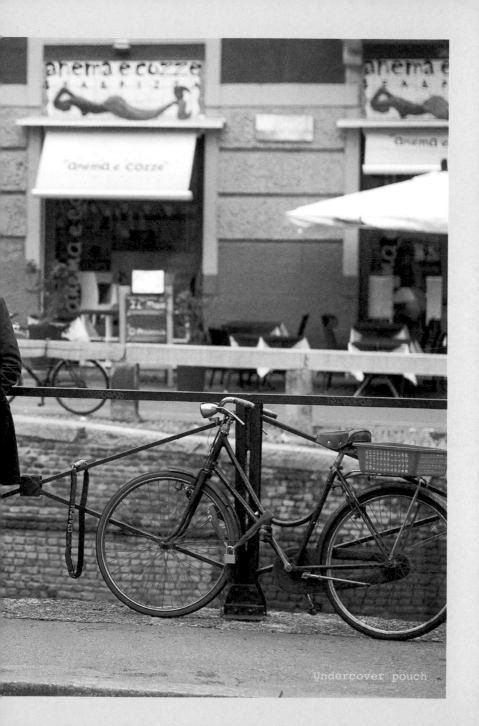

Undercover pouch

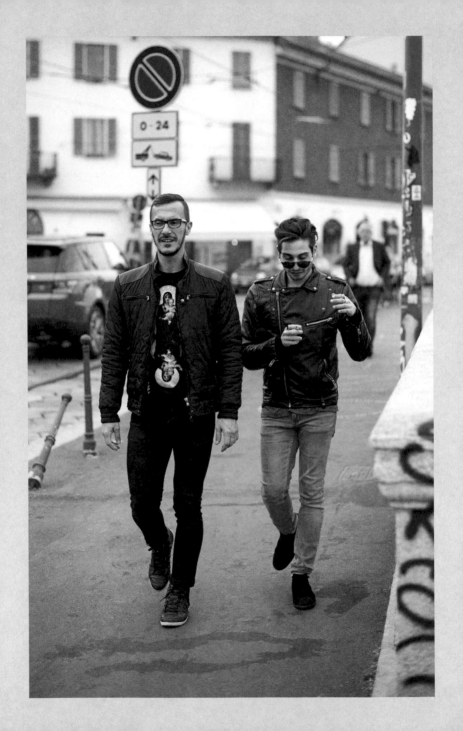

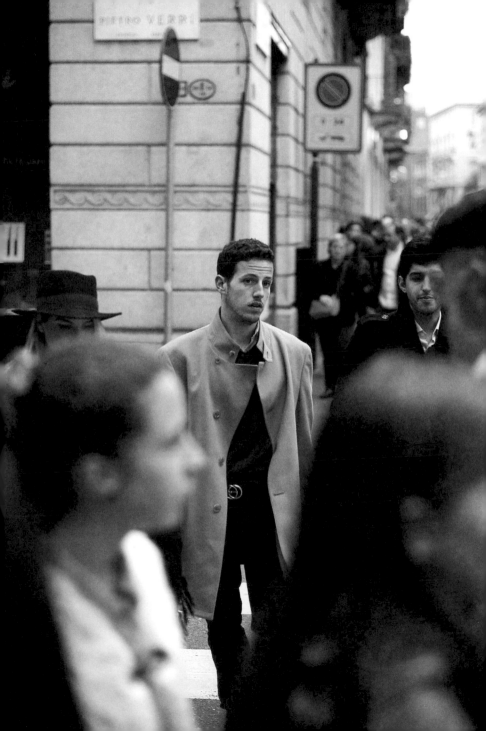

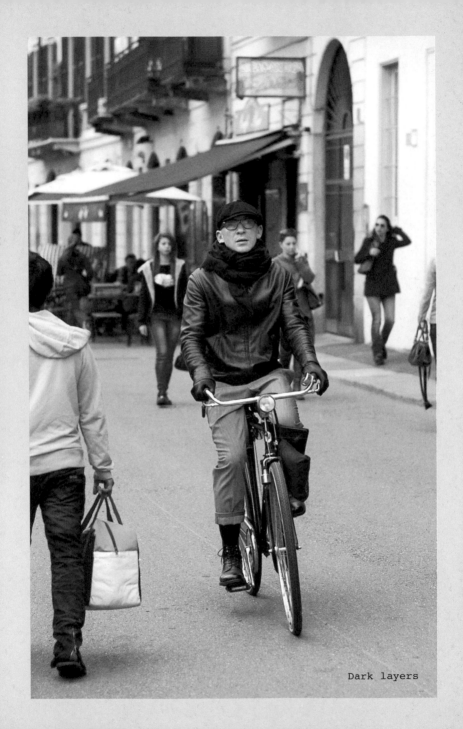

Dark layers

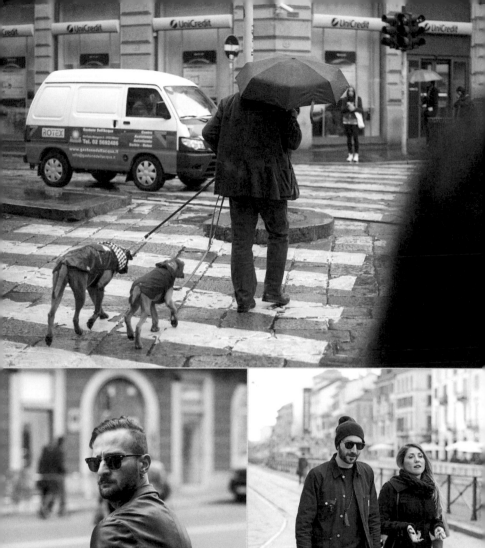

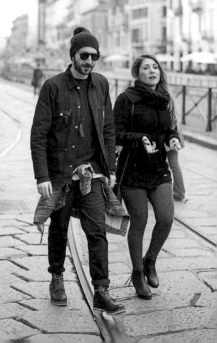

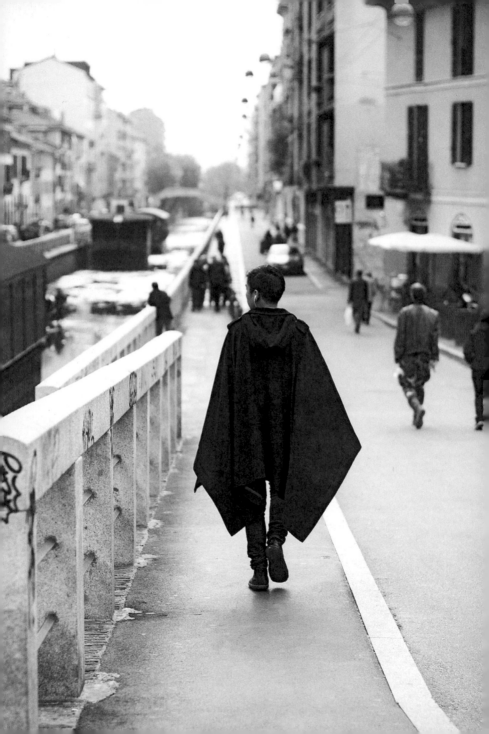

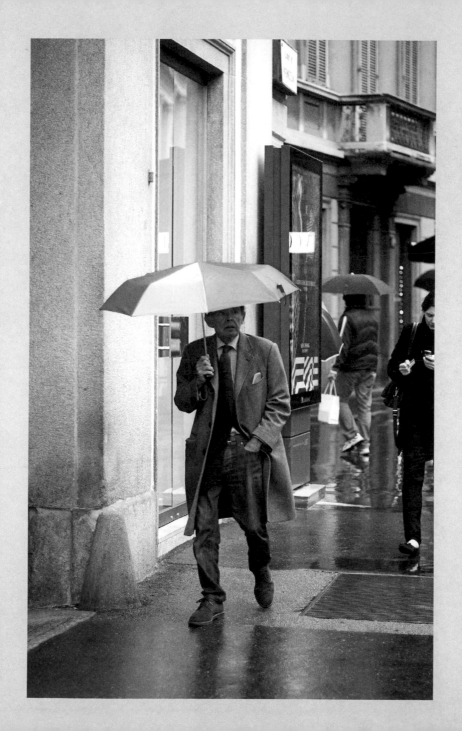

Seen on Corso di Porta Ticinese. This man defines the current look in Milan: modern sportswear combined with classic sartorial elegance.

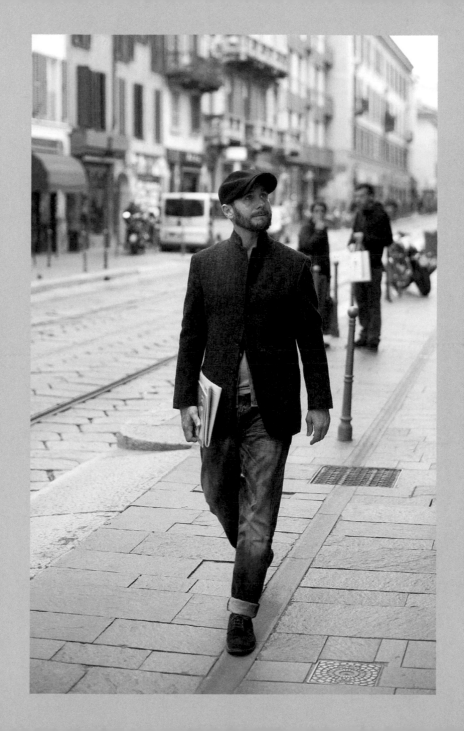

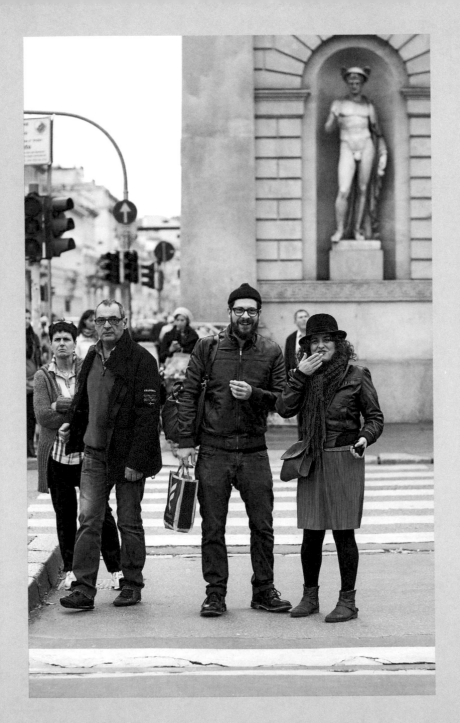

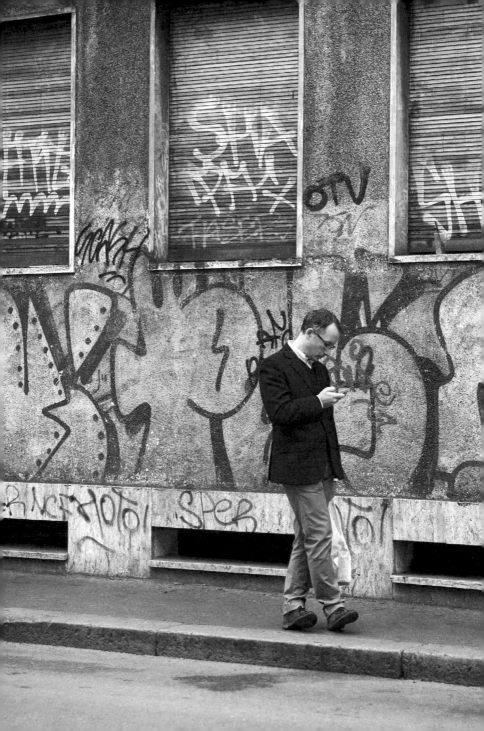

TOWN

New York

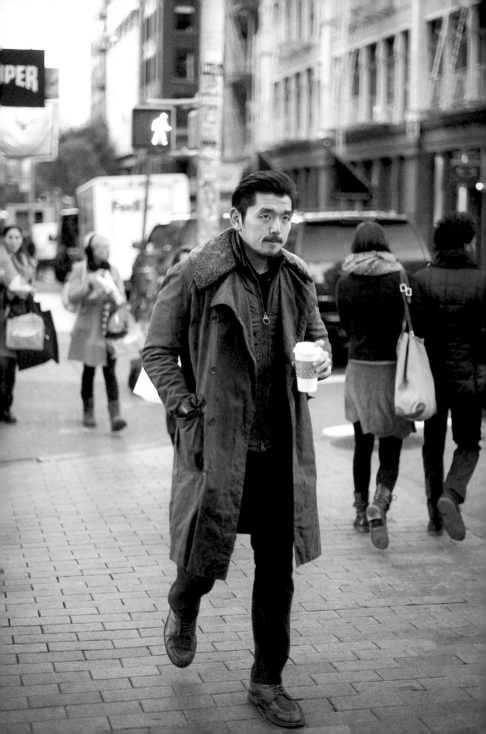

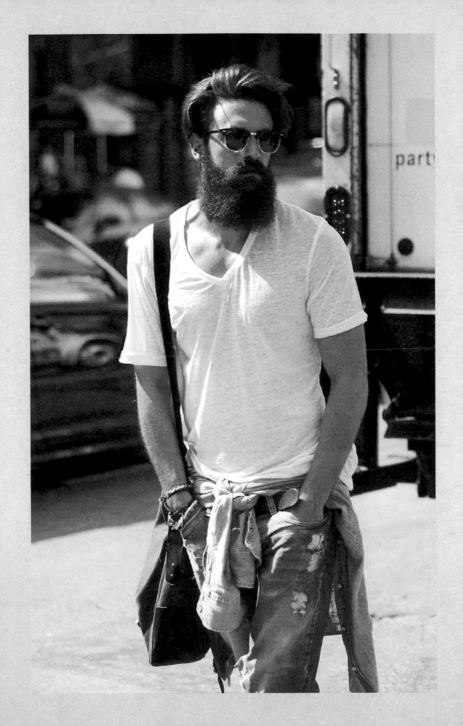

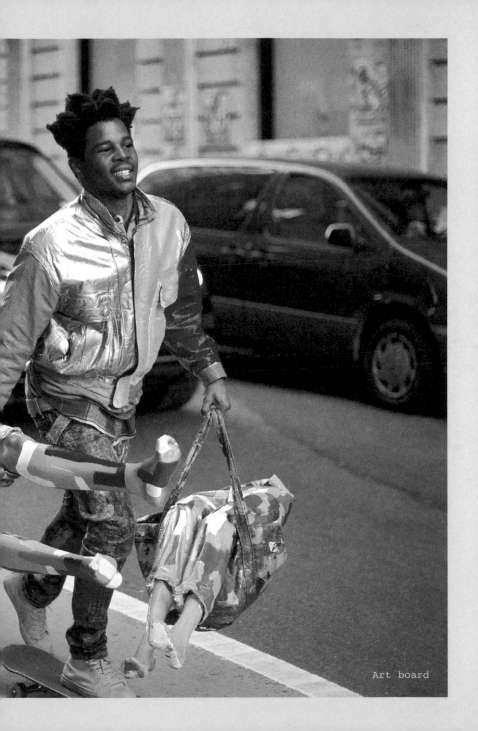
Art board

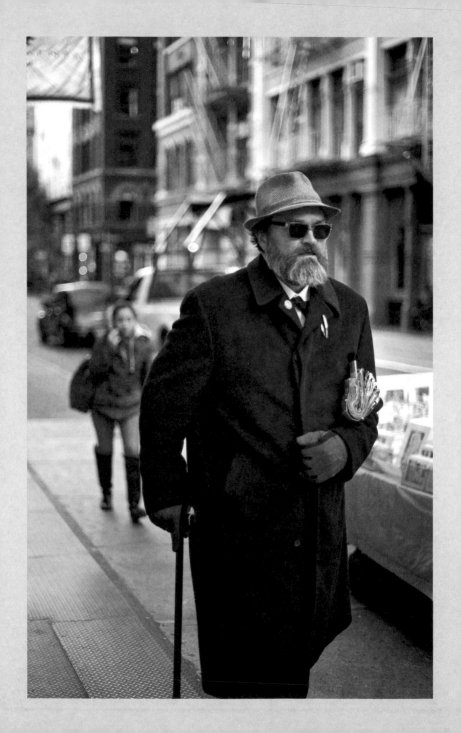

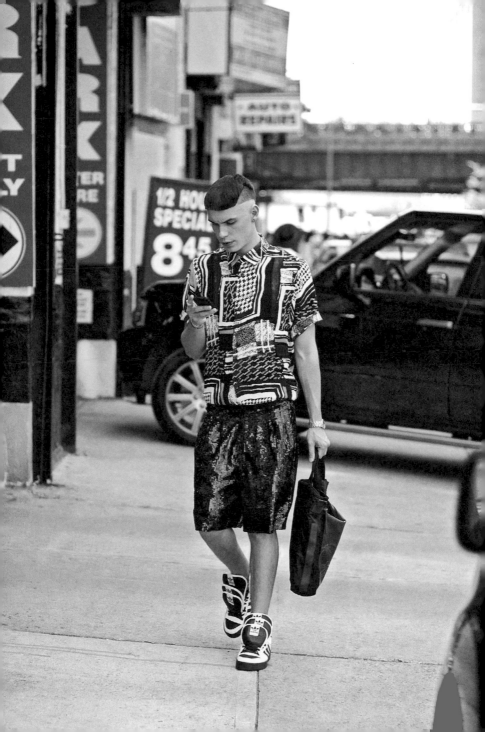

Nowhere but New York does a mode of transport become such a fashion statement. Cycling through Little Italy.

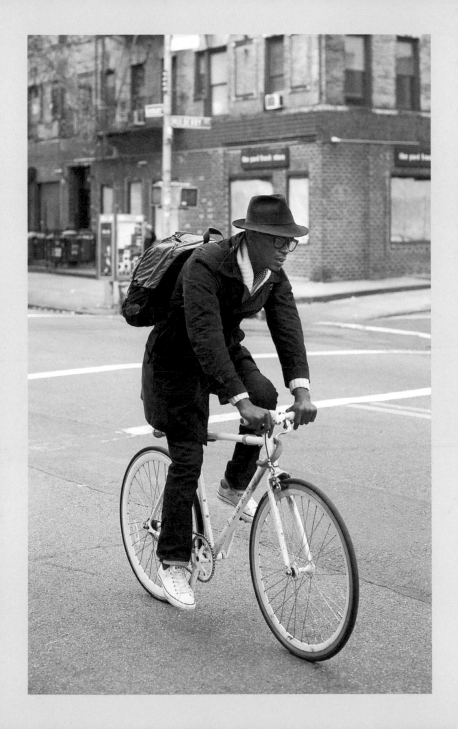

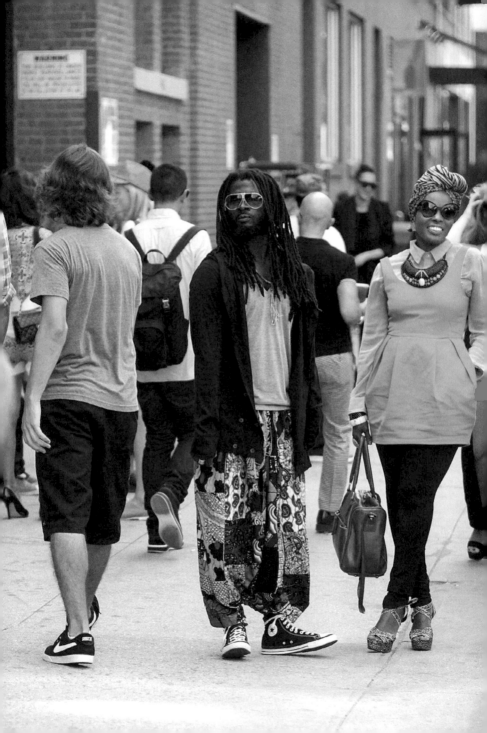

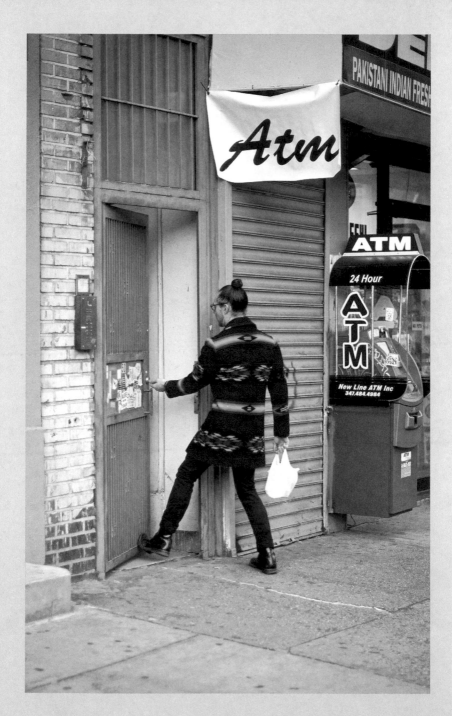

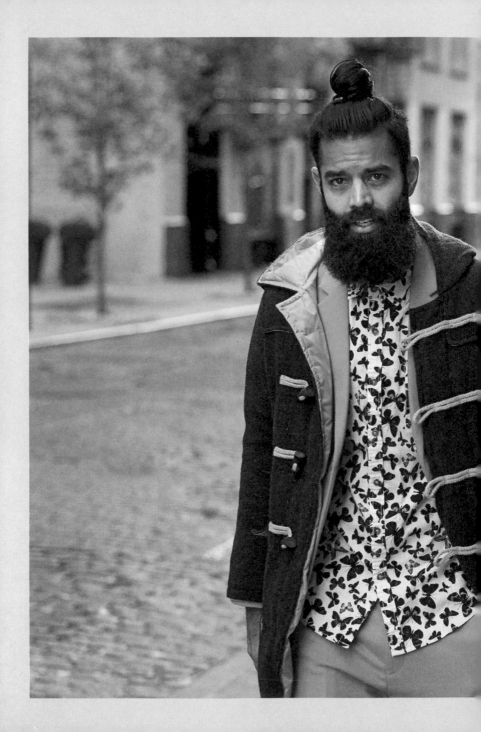

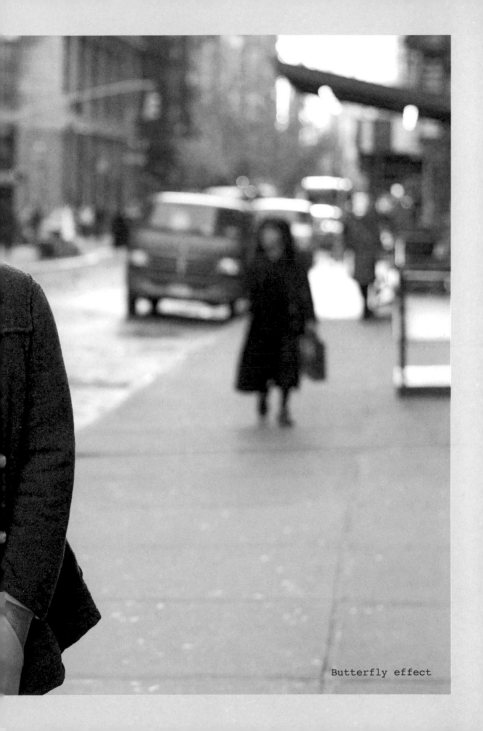

Butterfly effect

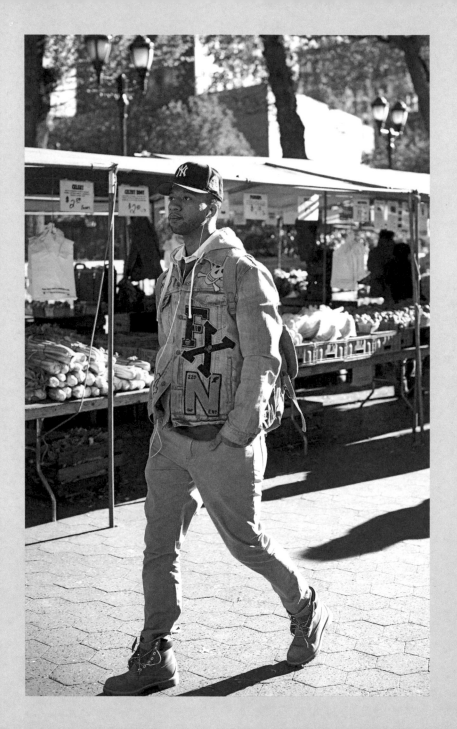

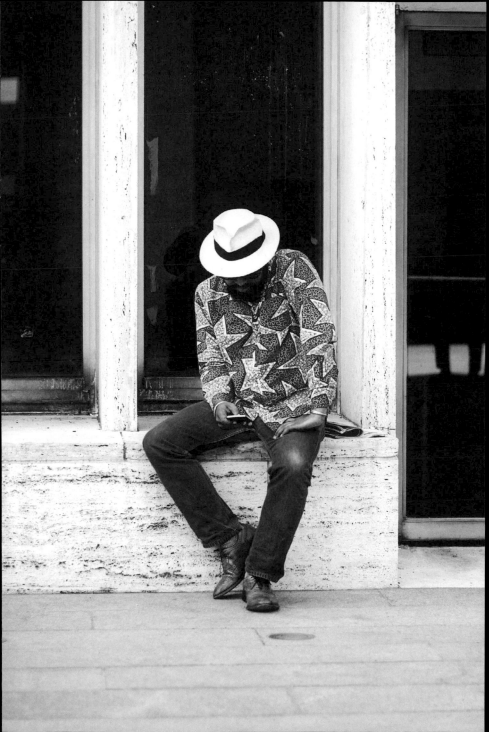

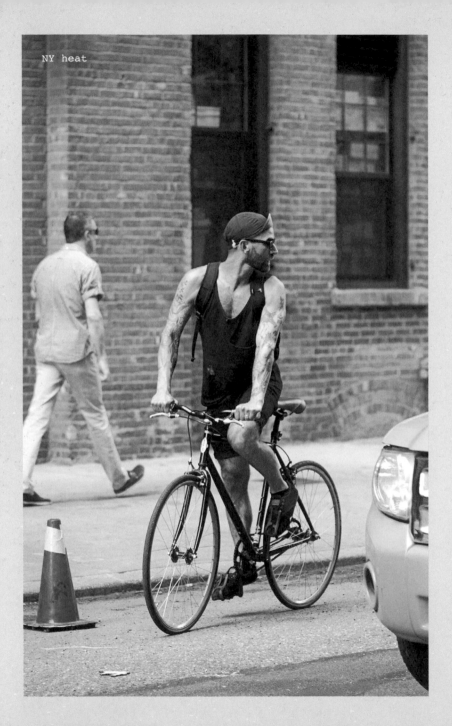

NY heat

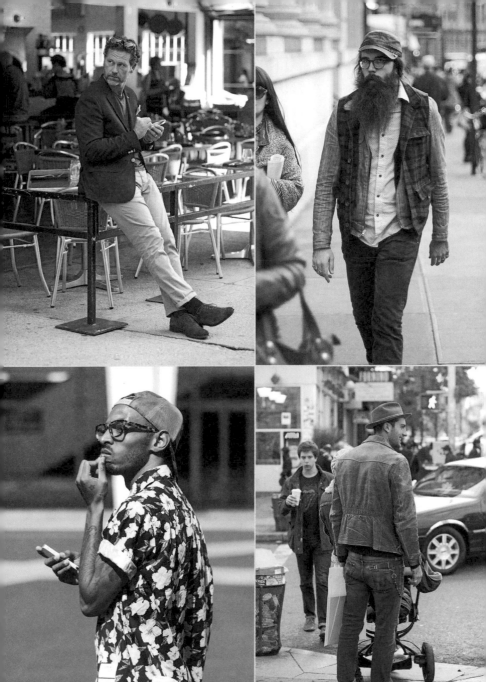

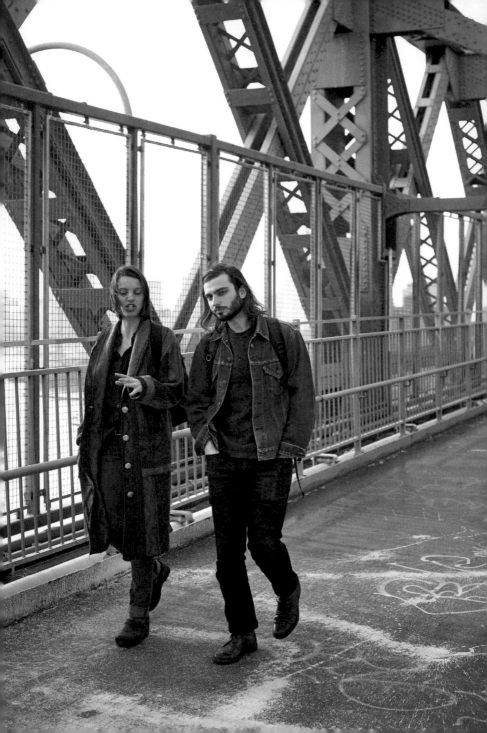

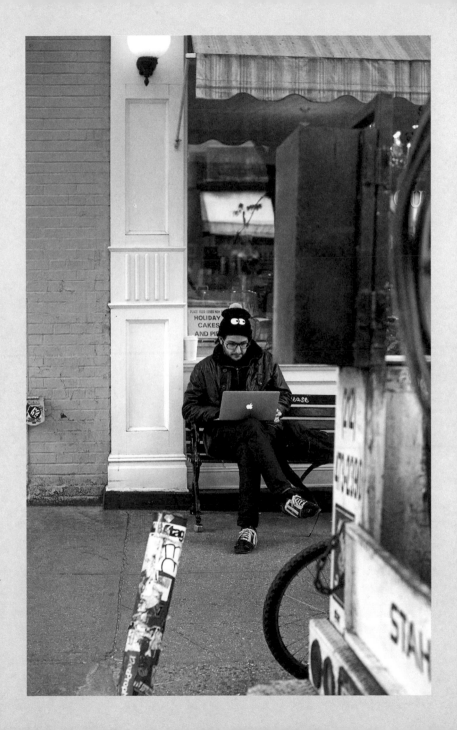

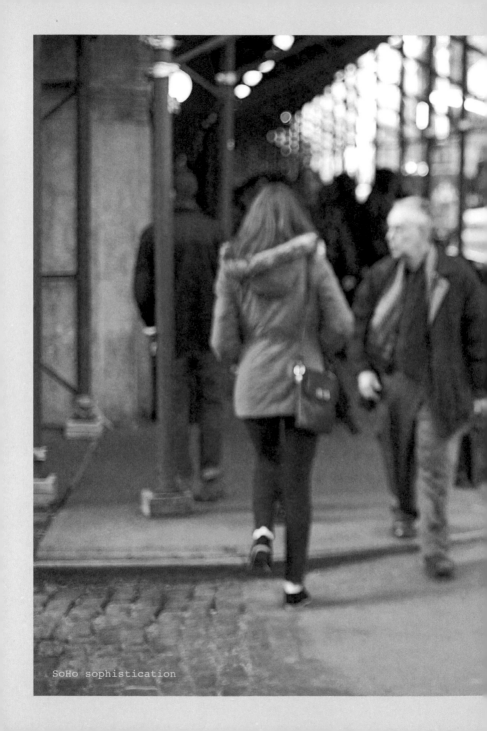

SoHo sophistication

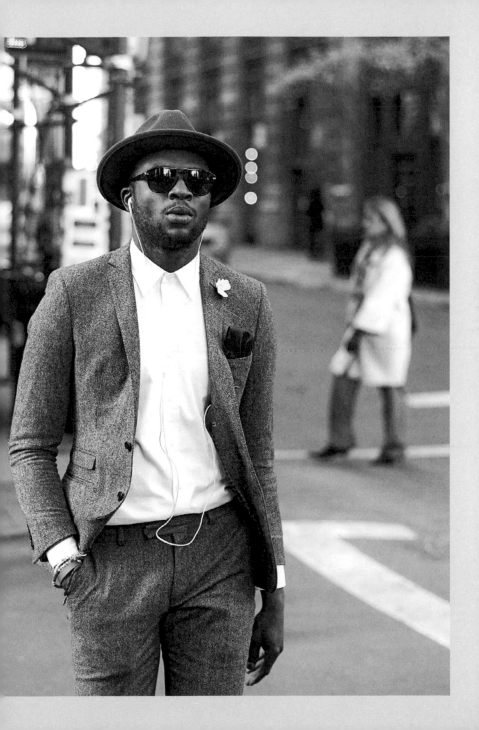

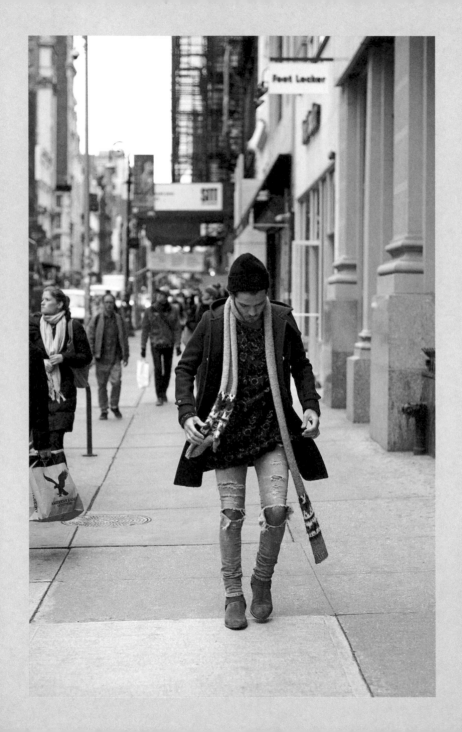

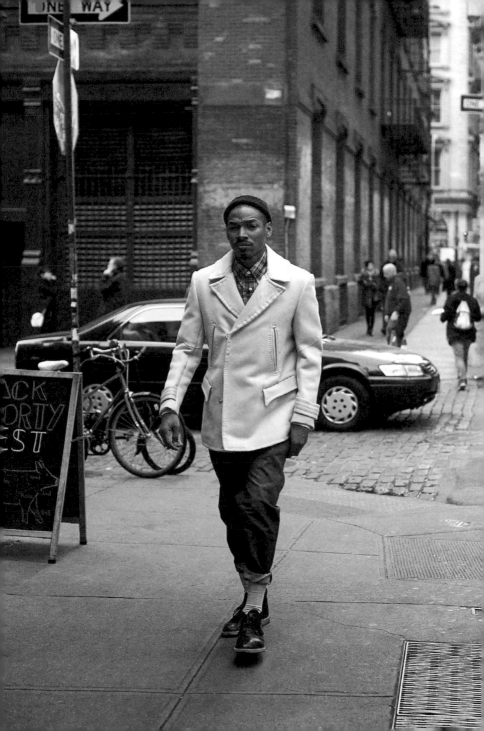

Robert Tagliapietra and Jeffrey Costello in *New York*

Robert (right) and Jeffrey are the masterminds behind New York–based womenswear label Costello Tagliapietra. I had the pleasure of meeting the couple in their Brooklyn home that once served as their studio. Having lived in the New York borough for the last 16 years, they've seen their personal style go from out-of-the-box to run-of-the-mill – worldwide.

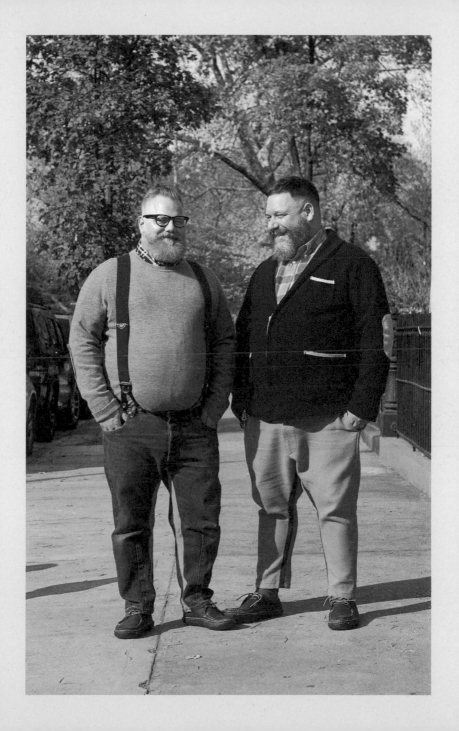

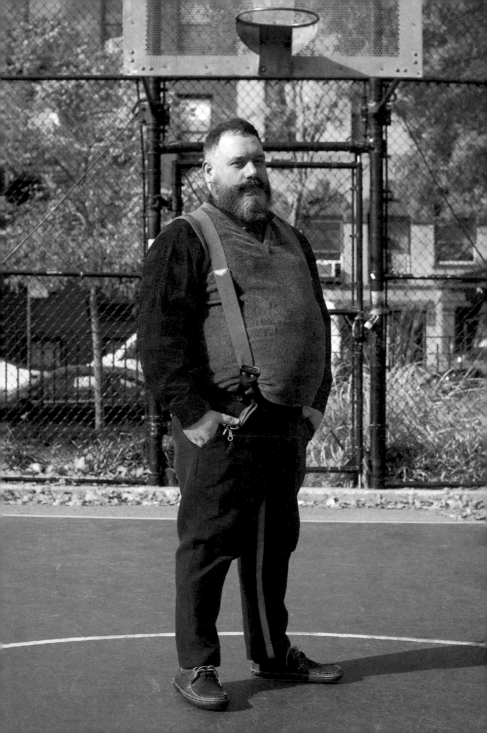

On their personal style

RT: Right now, I'm responding to things that have a little more life to them, almost touching on the dandy thing. I like a little bit of quirk in my clothing. I always think of an imaginary art dealer in his fifties, living in SoHo in the eighties and nineties. It's a strange amalgam of different things.

JC: I've always thought of my style as New England college professor mixed with a little lumberjack, a little woodsman – a slight masculine aesthetic with some dandy thrown in.

On their style progression

RT: When we met in 1994, I was wearing suspenders and plaid shirts. The grunge period was just fading. We've been together for almost 20 years; it's funny how things have become so cyclical. We've pulled out our old jodhpurs and vests that we wore 15 years ago and we're wearing them again now. Even though the aesthetic is similar and the pieces are the same, their meaning has evolved.

JC: As a kid, this was pretty much how I dressed. But then I went through this New Age/punk phase, which I'm glad didn't last very long. Then I just slid back into this. As you get older, you start to fine-tune your look. It becomes a little more personalised.

On their inspiration

RT: I speak for both of us when I say that our grandfathers were a big influence. They lived in suspenders and plaid shirts. I always loved that as a kid. My grandfather had this particular plaid shirt that he wore in his workshop and I'm always searching for a plaid that looks like it. The second I see one, I buy it. There's an emotive quality to patterns and colours and for me that print means something.

On their interest in fashion

RT: I grew up with people sewing around me; my grandmothers were seamstresses, my uncle was a designer. Sewing became a way for me to make things that I couldn't find. In those days fast fashion wasn't what it is today. It was harder to find something that you wanted to wear and to define yourself as a teenager. I would shop at thrift stores and buy things that were not always the perfect size, and I was at the mercy of that. So I had to alter things and change things. That kind of play made me want to become a fashion designer.

JC: Mine is a similar story. Our grandmothers worked together at Norman Norell and we didn't know it until we were together for five or six years. I loved to hang out with my grandmother, watching her sew. She taught me the art of pattern-making and how to make my first garment. I have always felt the love for fashion.

On the Brooklyn look

RT: There are a lot of beards in Brooklyn. We've been in Brooklyn since 1998 and we've seen it change. We used to be strange-looking in the neighbourhood and are now run-of-the-mill. That's been strange. I mean, there are now restaurants in Brooklyn where every guy wears suspenders – it has almost become a little bit cartoonish. It'll be interesting to see how that evolves. We are starting to see people a little more dressed up now. We're at a peak with flannel shirts and beards and we'll see where it goes.

JC: I think the Brooklyn look has become so global. We have friends coming back from Paris and saying that everyone is obsessed with Brooklyn, talking about it like it's another world. It's such a definitive style. I think that it's representative of what's going on in New York.

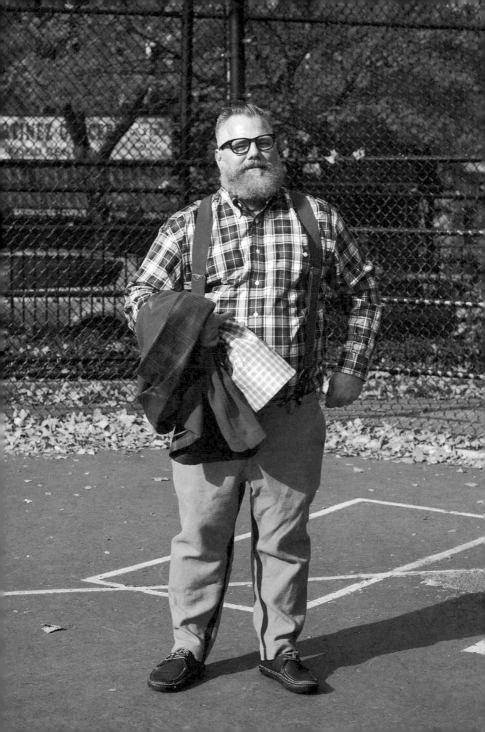

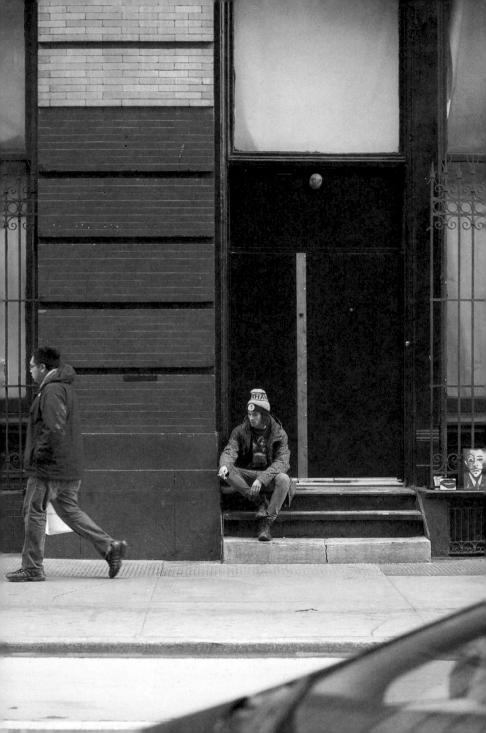

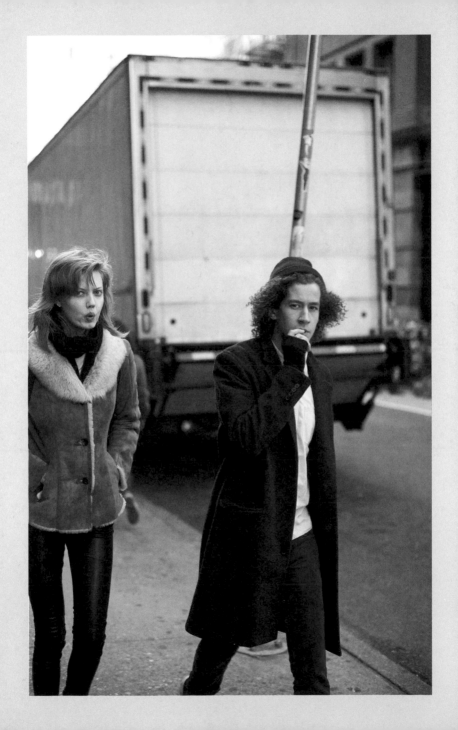

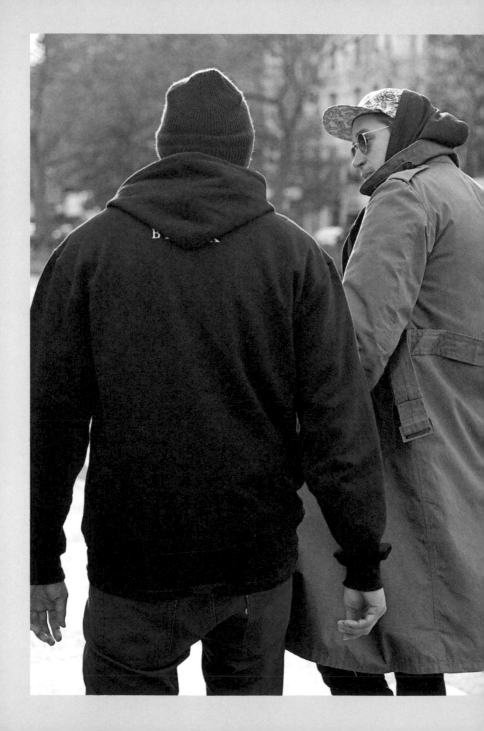

New York trenches

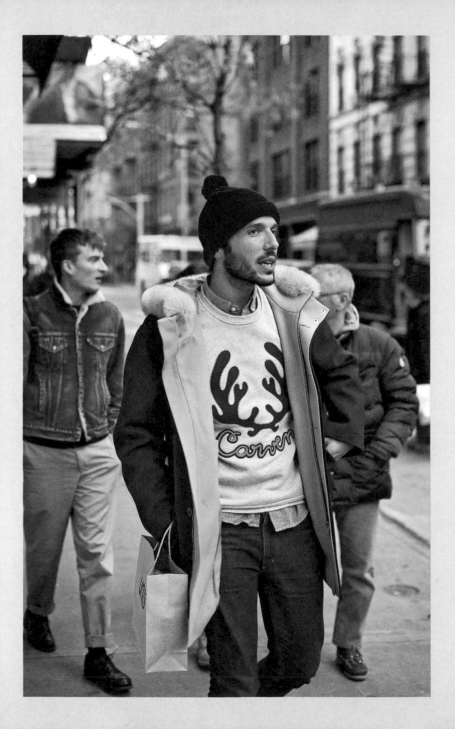

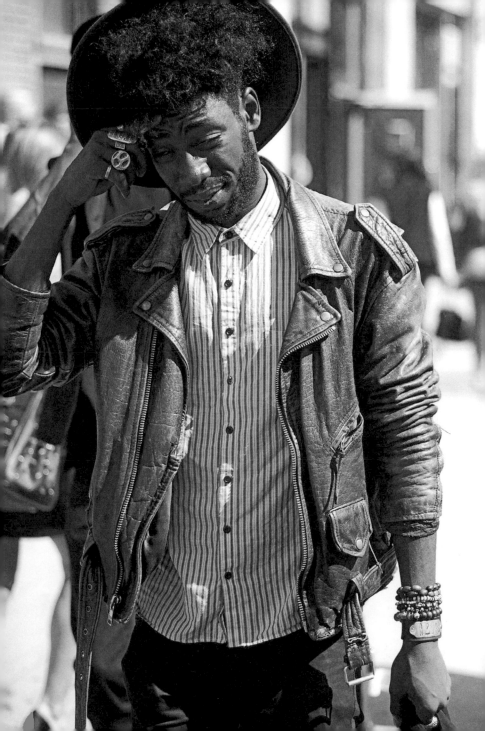

Still looking cool at the end of New York Fashion Week. On his way out from Chelsea Piers.

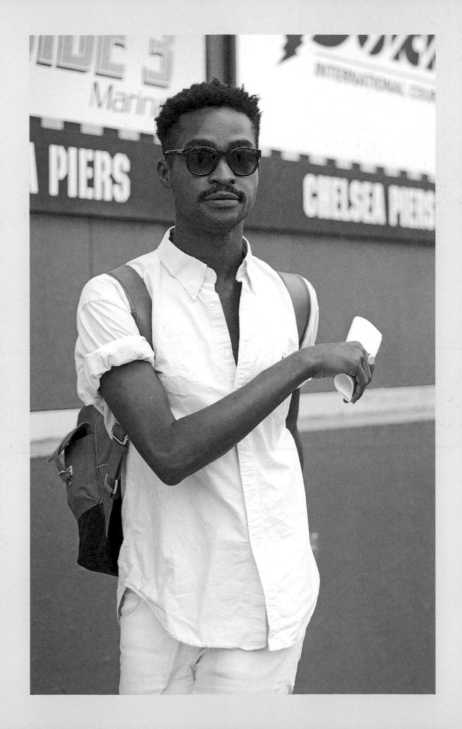

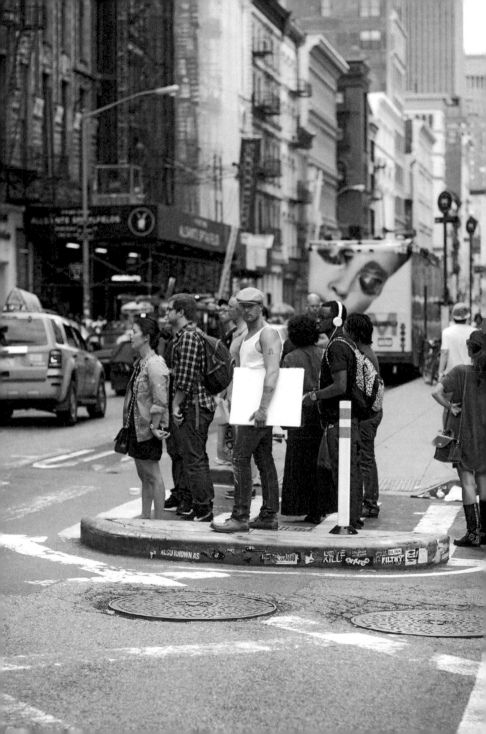

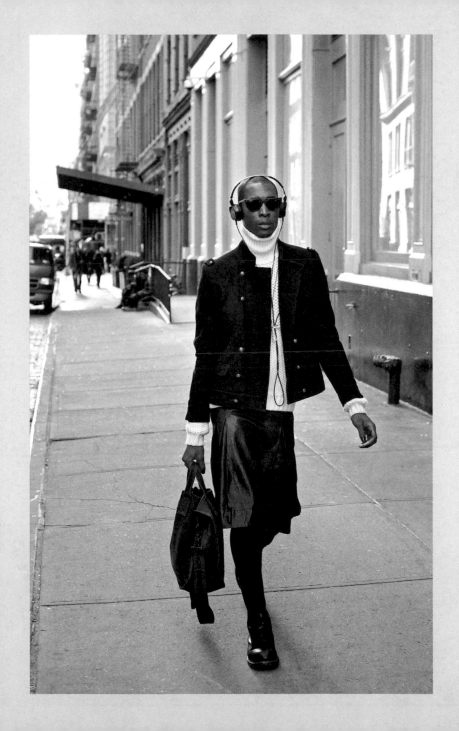

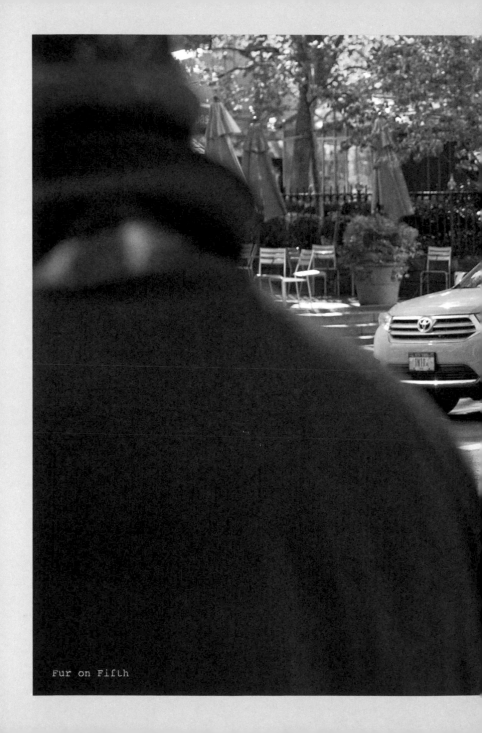

Fur on Fifth

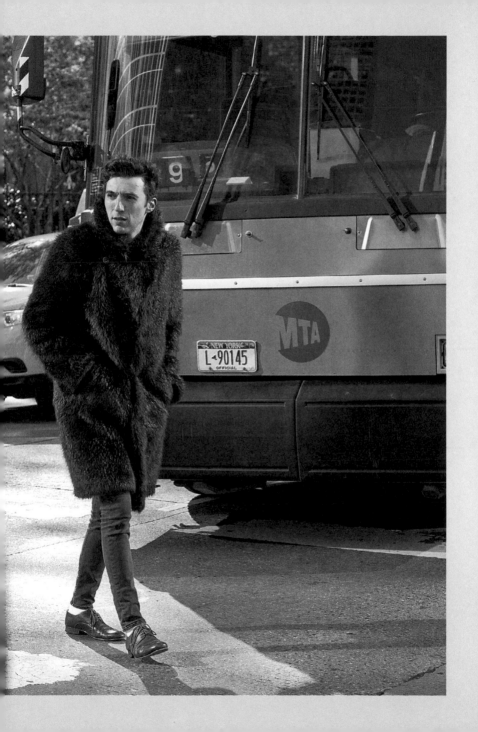

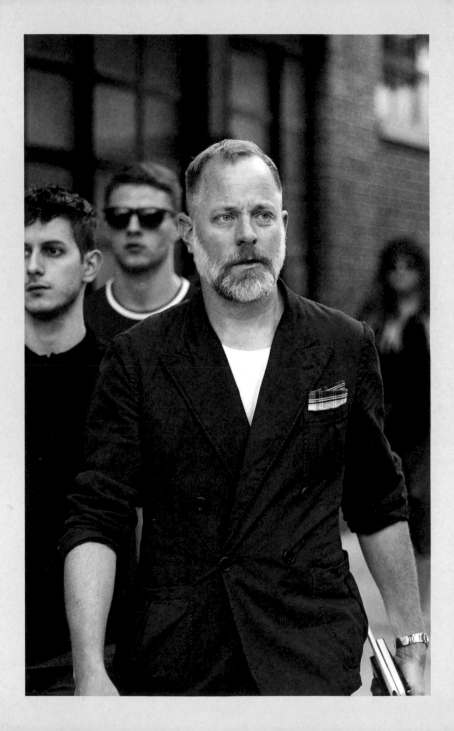

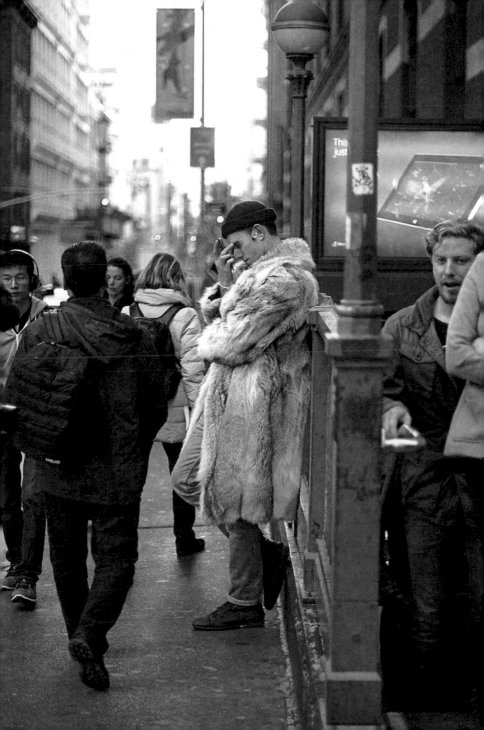

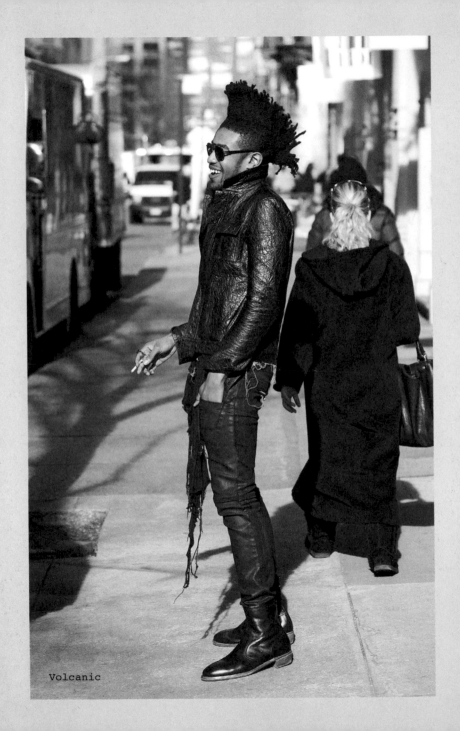

Volcanic

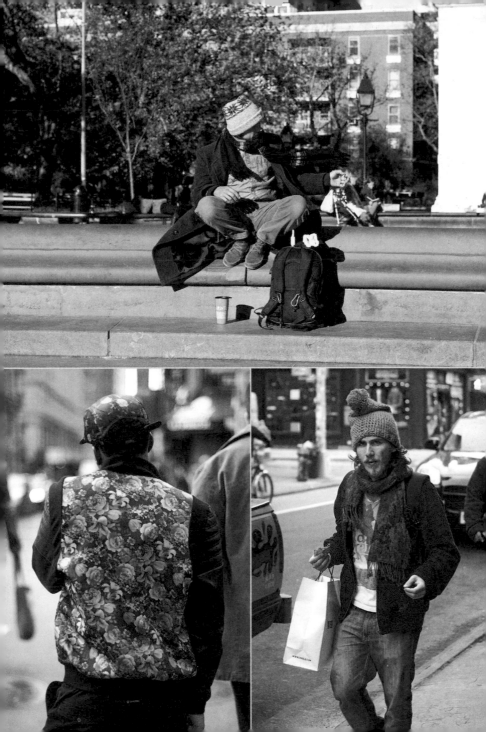

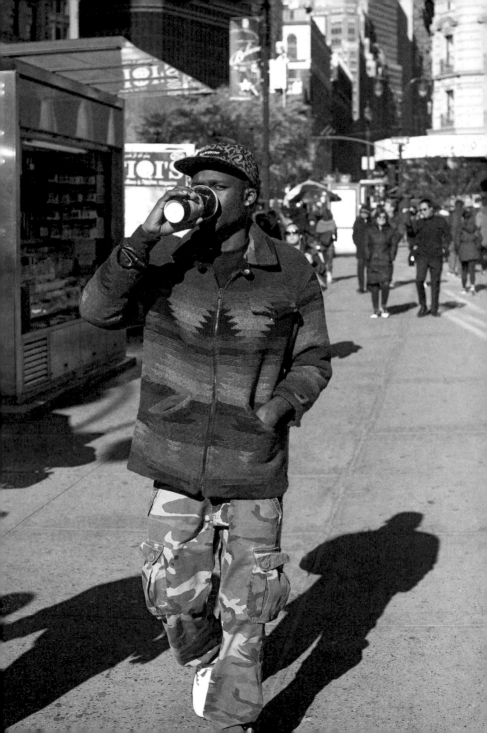

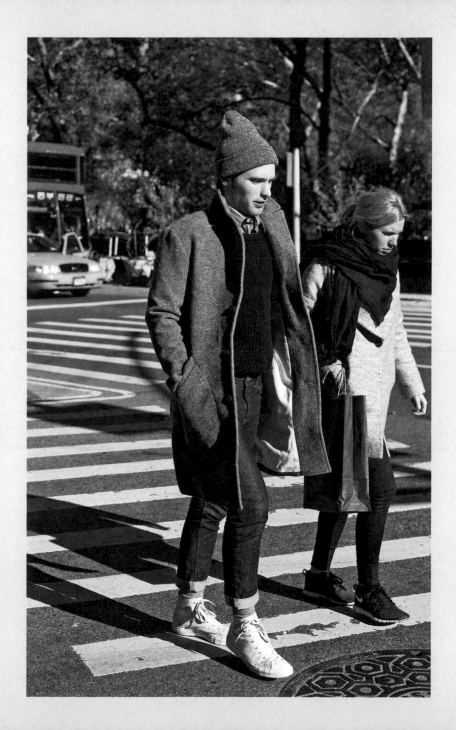

NOTES

A sign of the times.
Never unwired in SoHo.

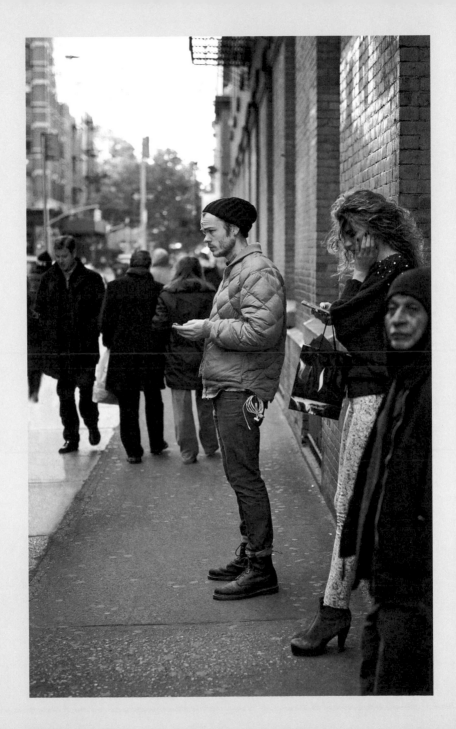

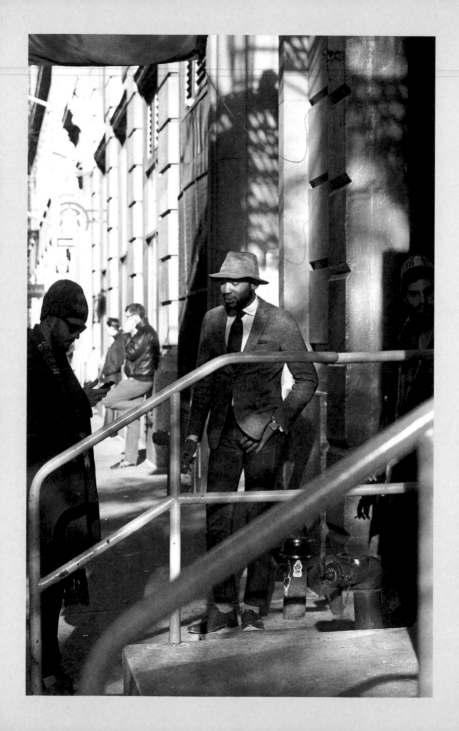

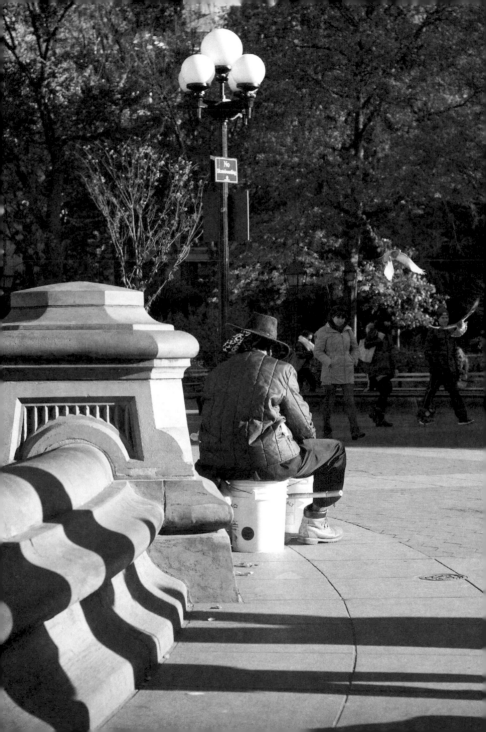

ACKNOWLEDGEMENTS

To Josh, for your unconditional love and support.
You are my rock and your spirit continues to
inspire me every day.

To my mom and dad, thank you for giving me
the freedom to live this extraordinary life. Your
love is still felt across the world. Even you, Paul
and Steve.

Dom, thank you.

Thank you to Hardie Grant for believing in this
project and to Paul McNally and Meelee Soorkia
for pushing me to make this book the best it
could be. Your knowledge in the art of book-
making is incredible and I am lucky to have
worked with you both.

To the men profiled in this book, your words
were inspiring and I thank you for your time.

Thank you to my audience for following my
work over the years. I hope at least one image in
this book will speak to you in some way.

Also a shout-out to Tumblr for providing a
platform to help share my work with the world.

And to Baxter, for being the best buddy a man
could ask for.

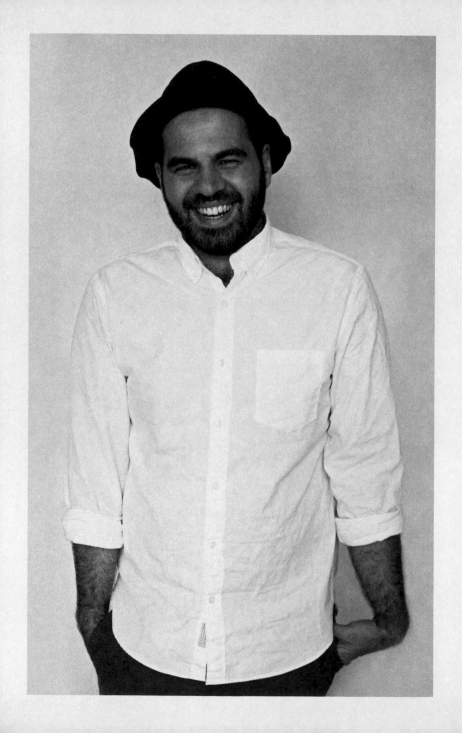

ABOUT THE AUTHOR

Giuseppe Santamaria is a photographer and
graphic designer from Toronto, Canada. He
moved to Sydney, Australia, eight years ago and
lives with his partner, Josh, and Baxter, their
Boston terrier.

Follow his work at *meninthistown.com*
and his life through pictures on Instagram
@giuseppeinthistown.

Published in 2014 by Hardie Grant Books

Hardie Grant Books (Australia)
Ground Floor, Building 1
658 Church Street
Richmond, Victoria 3121
www.hardiegrant.com.au

Hardie Grant Books (UK)
Dudley House, North Suite
34–35 Southampton Street
London WC2E 7HF
www.hardiegrant.co.uk

Cataloguing-in-Publication data is available from the National Library of Australia.
Men in this Town
ISBN 978 1 74270 781 5

Publishing Director: Paul McNally
Project editor: Meelee Soorkia
Designer: Giuseppe Santamaria
Production Manager: Todd Rechner

Colour reproduction by Splitting Image Colour Studio
Printed and bound in China by 1010 Printing International Limited